ALONG THE
KENT
COAST

To George
H
Grace

ALONG THE
KENT
COAST

RAY HOLLANDS & PAUL HARRIS

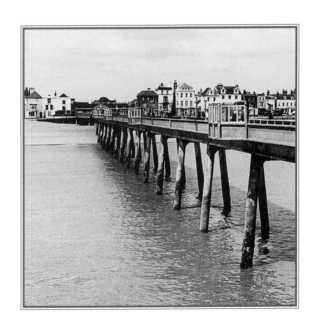

SUTTON PUBLISHING

Sutton Publishing Limited
Phoenix Mill · Thrupp · Stroud
Gloucestershire · GL5 2BU

First published 2003

Copyright © Photographs: Ray Hollands, 2003
 Text: Paul Harris, 2003

Title page photograph: Deal pier.

British Library Cataloguing in Publication Data
A catalogue record for this book is available from the
British Library.

ISBN 0-7509-3405-0

Typeset in 10/12 Gill Sans.
Typesetting and origination by
Sutton Publishing Limited.
Printed in England by
J.H. Haynes & Co. Ltd, Sparkford.

Dover inner harbour, very much a sailing and windsurfing venue.

CONTENTS

The remains of sea defences at Dymchurch, obviously a hazard at low tide.

FOREWORD

The idea of walking and photographing the coast of Kent had been formulating in my mind for some time. The county's natural geological diversity and geographical and historical position prompted more than a casual investigation, and once embarked upon the journey I was hooked. My journey on foot covered over 250 miles of the Kent coast's total length of some 350 (by coast I mean any inlet, river or creek that can claim to be tidal). Certain sections naturally lent themselves to being photographed from the water. Not being entirely amphibious, the occasional use of a boat seemed prudent.

Photography has many different forms and styles but I believe its power lies in its ability to document places in a landscape or moments in time, and even just an interpretation of the way things are. I endeavoured whenever possible to take photographs that were stand-alone images, with the proviso that they should in no way diminish the visual narrative of the exercise. I make no excuses for having chosen certain subjects in preference to others and offer no apology for those omitted. I photographed what I saw. I hope that the pleasure I have experienced while walking and photographing the Kent coast has in some small way manifested itself in the images presented here.

Ray Hollands
2003

ACKNOWLEDGEMENTS

The authors would like to thank all those who helped in the preparation of this book. Particular thanks go to Pamela Hogg for diligently typing the text; Barbara Leach of Pfizers for information with regard to the Hands and Molecule sculpture; the Tourist Information Offices at Broadstairs, Herne Bay and Whitstable, whose staff answered so many of our questions about their respective areas; Mike Fawke for arranging a marvellous excursion; Dorothy Harris for preparing the index at such short notice; and lastly Di for her unfaltering support and patience in being excluded from the utility-cum-darkroom.

INTRODUCTION

There is something very special about the coast, that ever-changing strip of land that forms an interface between the world of man and the raw power of nature. The eternal conflict between land and sea, between invaders and defenders, between the needs of humankind and the vagaries of wind and tide, has created a wonderfully diverse and atmospheric environment, both natural and man-made.

Nowhere is this more true than along the coast of the county of Kent. Here you will find the famous White Cliffs of Dover, which draw visitors in their thousands from all over the world. Here too are magnificent castles, wartime relics, eerie concrete sound mirrors, wide sandy beaches, sheltered bays and the largest shingle expanse in Europe. Abundant reminders of every period of the country's history and examples of most types of coastal terrain are to be found here.

For those of a literary bent, the Kent coast boasts sites that inspired authors as diverse as H.G. Wells, Russell Thorndike, Ian Fleming and Charles Dickens.

Inspiration is what Ray Hollands draws on for the photographic journey that unfolds in this book – a journey that will, I hope, encourage the enjoyment and appreciation of this coast not only by visitors but also by existing residents who may view their familiar environment in a new light.

Paul Harris
2003

Kent coastline showing the sites of the photographs.

Chapter One

ROMNEY MARSH

Described by author Richard Barham as the 'Fifth Continent', Romney Marsh is a lonely expanse of land gradually reclaimed from the sea since Roman times. At one time the Marsh, as it is known locally, was a remote, secretive and mysterious place. It was a land of mist and swamp, of isolated villages and churches, peopled by close-knit communities, many of whom made a living by smuggling – as immortalised by Russell Thorndike in his *Dr Syn* books. In such a place anything might be possible. In *Puck of Pook's Hill* Rudyard Kipling spoke of fairies and will o' the wisps. Richard Barham in his mock medieval *Ingoldsby Legends* said that 'a witch may still be occasionally discovered in favourable, i.e. stormy, seasons, weathering Dungeness Point in an eggshell, or careering on her broomstick over Dymchurch Wall'.

That was 150 years ago. Today the Romney Marsh is drained by a series of dykes and ditches and is connected by main roads to Folkestone, Ashford and Hastings. A miniature railway links several Marsh villages. There is an airport at Lydd and a nuclear power station at Dungeness. It is still possible, however, to feel a sense of remoteness and isolation, particularly along the coast, where it's all sea and sky, sand and shingle, and man's impact on the scene, however successful, seems piecemeal, and dwarfed by the vast elemental forces of nature.

In this chapter we journey along the seaward perimeter of this strange landscape, from the shingle headland of Dungeness to the pleasant village of Sandgate, to experience something of the evocative, magical quality of this unique environment.

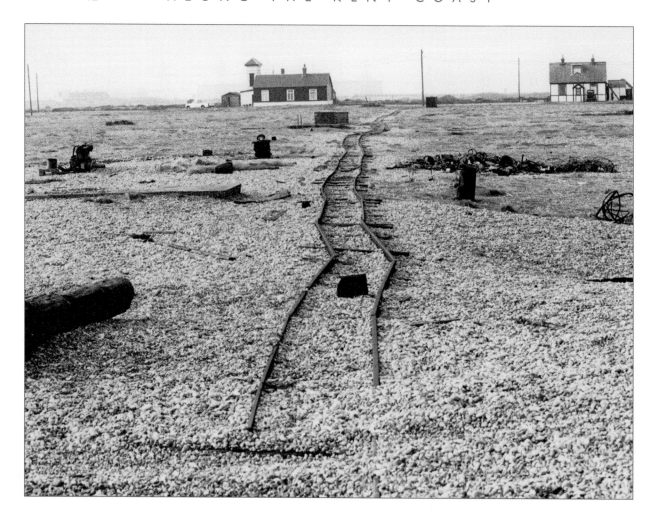

Dungeness, which boasts the largest expanse of shingle in Europe, is where we start our journey around the coast of Kent. The empty landscape has a certain bleak charm. Nothing is hidden. Signs of human activity, past and present, lie exposed to the eye and to the wind, sun and salt spray that scour this isolated promontory. The lonely atmosphere of Dungeness attracts not just fisherfolk, some of whom have lived and worked here for generations, but also writers, artists and photographers drawn by its stark, unique ambience and the clarity of its light.

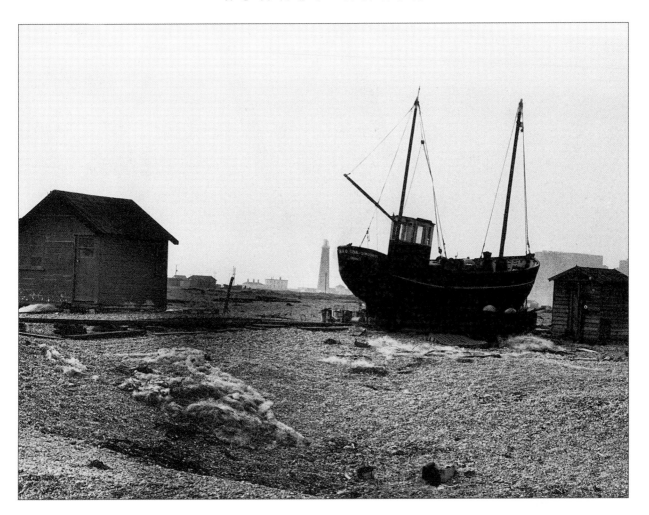

A haven for migrating birds, the shingle desert of Dungeness is dotted with fishing boats and their associated oily debris, flotsam, jetsam, huts and rope, rusty chains and wooden walkways. The walkways are essential since struggling across shingle can be hard work. Until recently locals used to make their way across it using 'backstays', the equivalent of snow shoes: these consist of rectangular flat pieces of wood with a leather strap into which the foot is slipped. It is said that some older residents still use them. Here is a typical scene at Dungeness. On the horizon can be seen the old lighthouse, built in 1904 and successor to an earlier one constructed in 1792. It is now open to the public, although it is being replaced by a new lighthouse. Beyond the fishing boat and hut can be seen the ominous grey bulk of the Dungeness nuclear power station, looming over this haunting expanse of salty desolation.

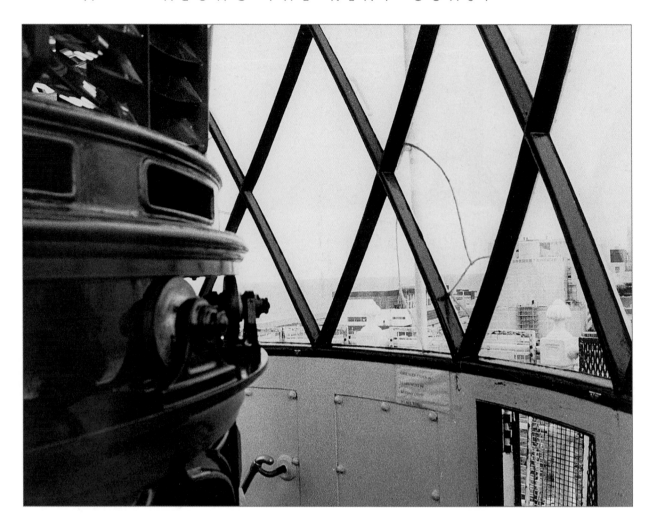

From the top of the 1904 lighthouse – an exhausting climb completed by thousands of visitors every year – the view is extensive. From here you can see across Romney Marsh to the White Cliffs of Dover beyond. In this picture we are beside the lighthouse lamp looking over Dungeness nuclear power station, built in the 1960s and 1970s and still producing electricity today. A visitor centre at the site offers detailed information.

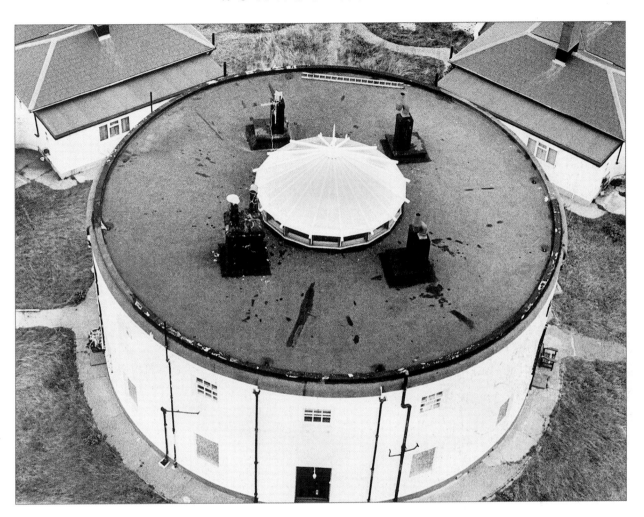

Another view from the lighthouse, overlooking the accommodation built for the keeper of the 1792 tower, which has long since gone. This attractive circular building has since 1994 been converted into private accommodation. The cupola on top was added quite recently.

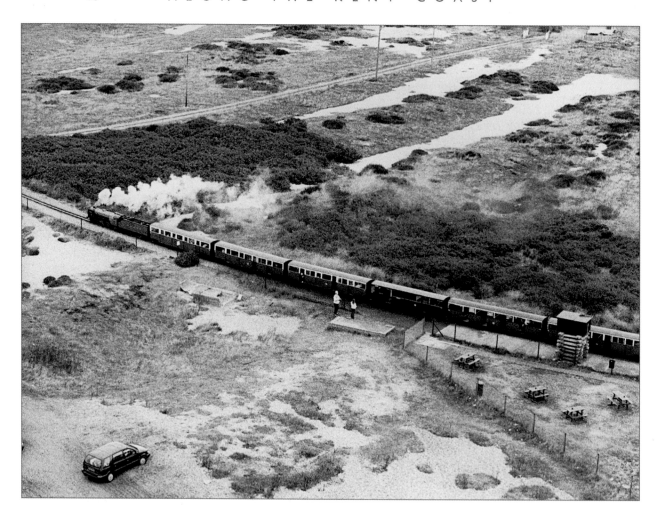

A final view from the lighthouse, this time showing the departure of the miniature train on the Romney,
Hythe & Dymchurch Railway (RH&DR) line, which terminates here. Said to be the world's smallest
public railway service, the line opened in 1927 as the brainchild of Louis Zborowski, who sadly died in a
motor racing accident before he could see his dream realised. The line runs between Hythe and
Dungeness with stops at Dymchurch, St Mary's Bay, New Romney, Greatstone and Lade.

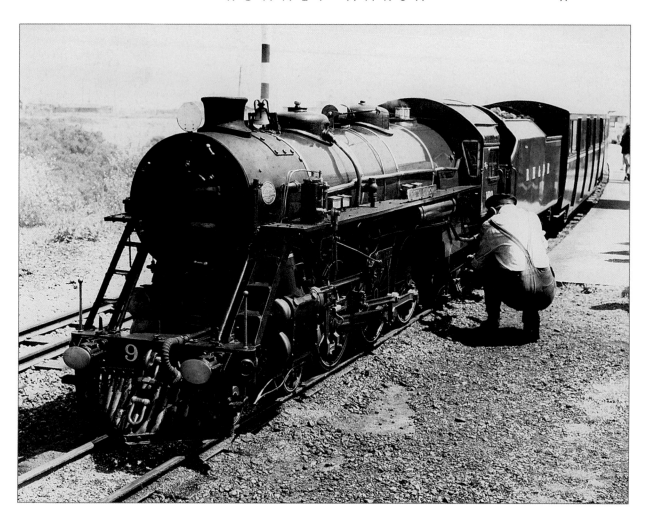

One of the superb miniature steam engines of the Romney, Hythe & Dymchurch Railway being prepared for the return journey from Dungeness. The line is popular with young and old alike throughout the year. It's not only visitors and day trippers who use the line: it provides a regular and reliable commuter service for schoolchildren across the Marsh.

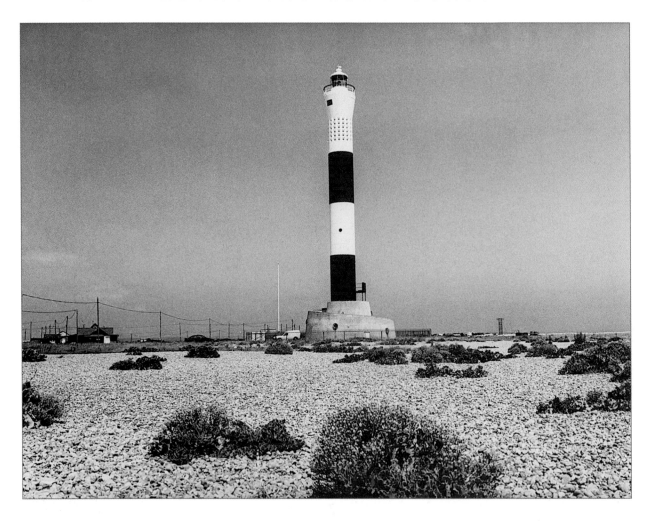

The most recent lighthouse on Dungeness, built in 1961, is fully automatic and provides a much-needed navigational aid in the busy sea lanes of the English Channel. Furthermore the lighthouse is essential at this point since the Dungeness promontory dangerously juts out into deep water. At over 143 feet it is one of the tallest in Britain.

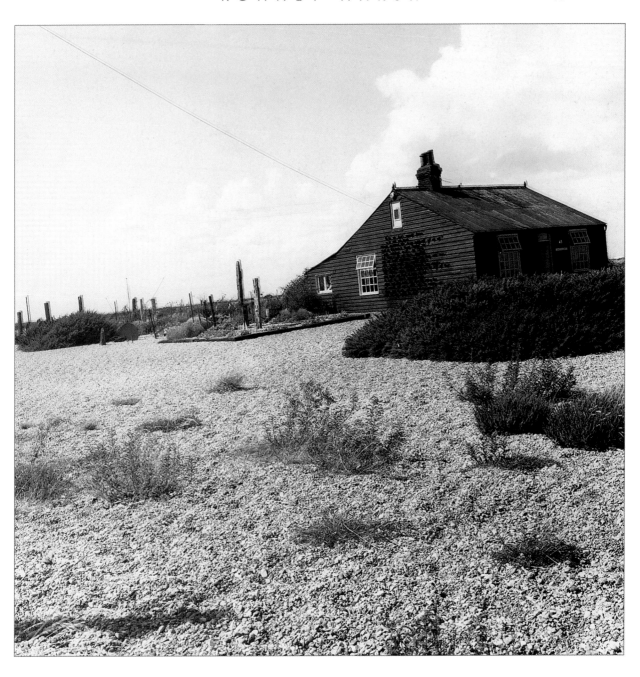

Above and the following two pages: Typical of the little houses scattered across the promontory of Dungeness, Prospect Cottage, with its famous and eccentric garden, was the home of the late Derek Jarman. The garden contains all kinds of unusual sculptures, in the shape of boats, fish bones and other objects found locally. Jarman was the producer of films such as *Edward II* and *Sebastian*. He loved the wildness of Dungeness, and Romney Marsh in general, and is buried beneath a distinctive black monolith in the graveyard of St Clement's Church at Old Romney.

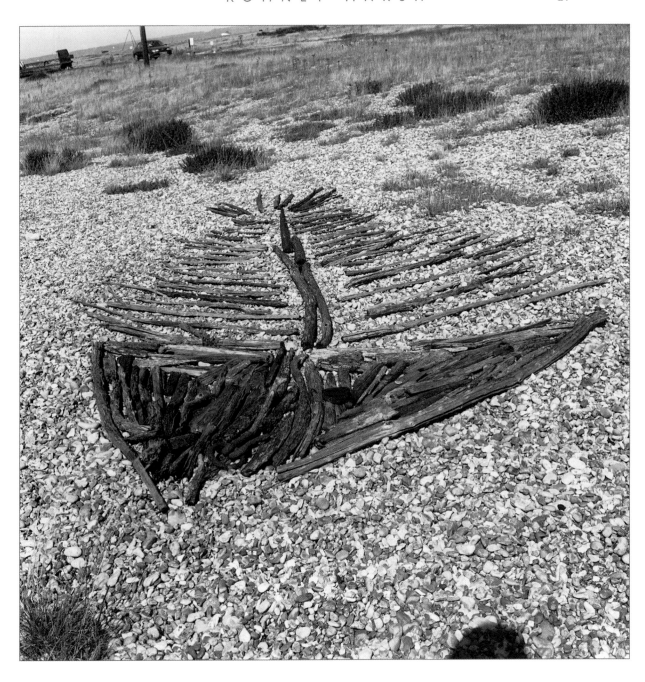

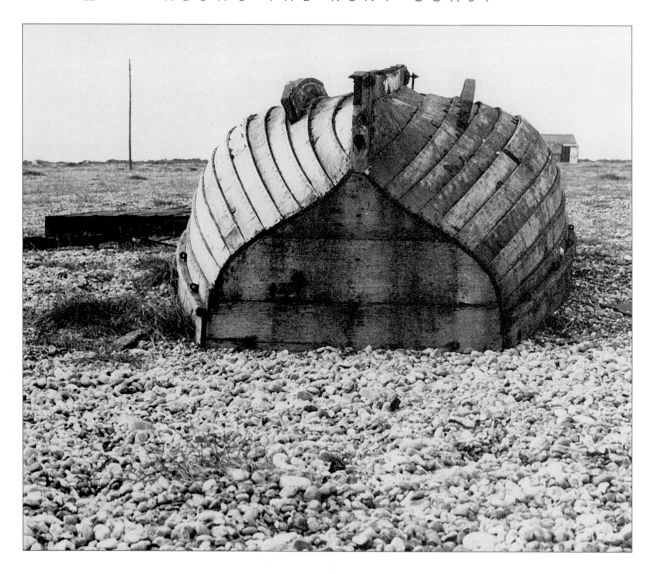

Above and opposite: For generations fishing has been the backbone of the Marsh economy. Locally caught fish are sold from outlets on Dungeness direct to the public and to nearby pubs whose fish and chip meals are legendary throughout the district.

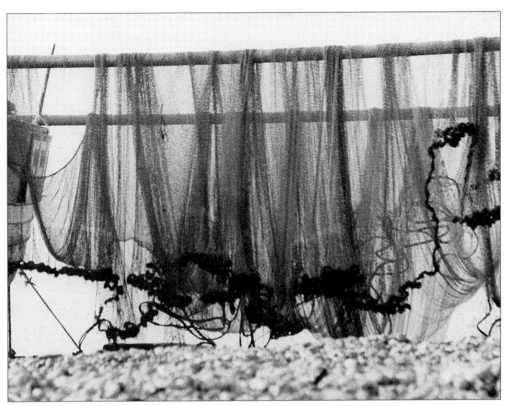

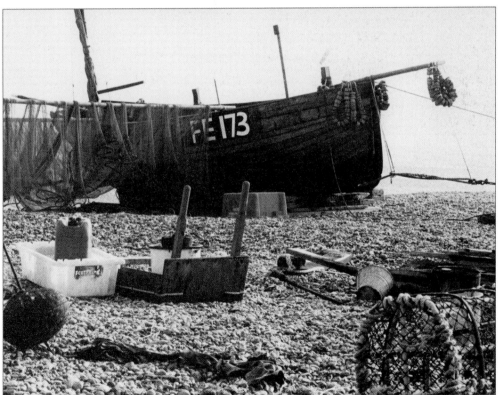

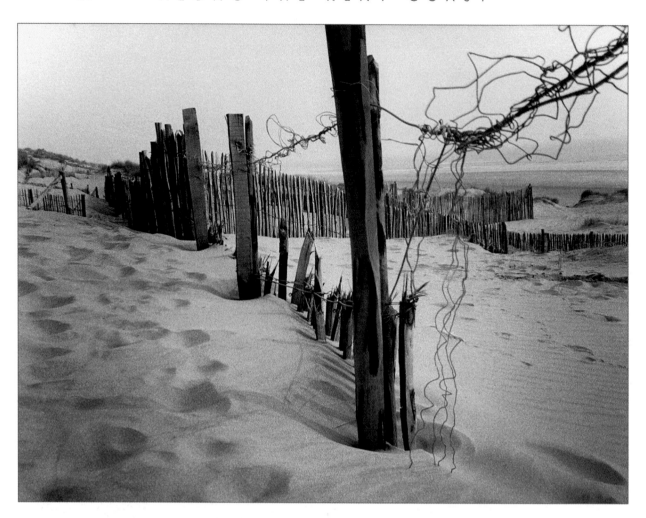

Just a few miles to the north-east and the scene changes dramatically. Shingle banks give way to sand dunes and a vast beach. Dunes such as these at Greatstone are surprisingly effective as a defence against incursions by the sea.

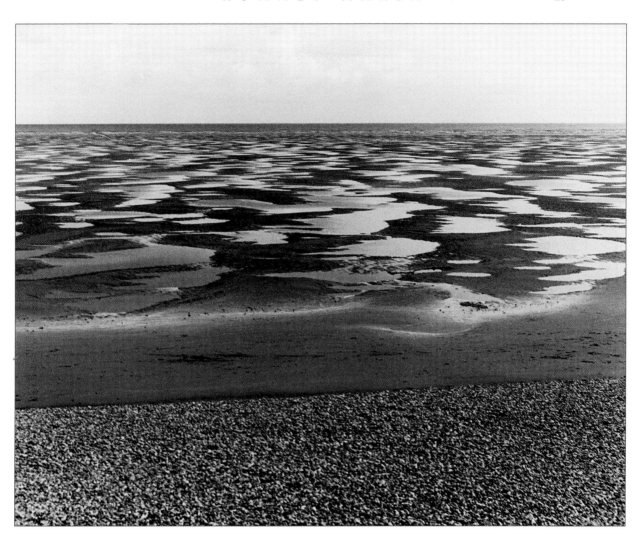

The expansive beach at Greatstone, where the tide retreats over half a mile from the shore. In this alluring landscape of sand and shallow pools dangerous quicksands can sometimes form and trap the unwary. In stormy weather all sorts get washed up here. In the last ten years or so a whale, a giant leatherback turtle and the serpentine remains of a basking shark have all found their way to this shore.

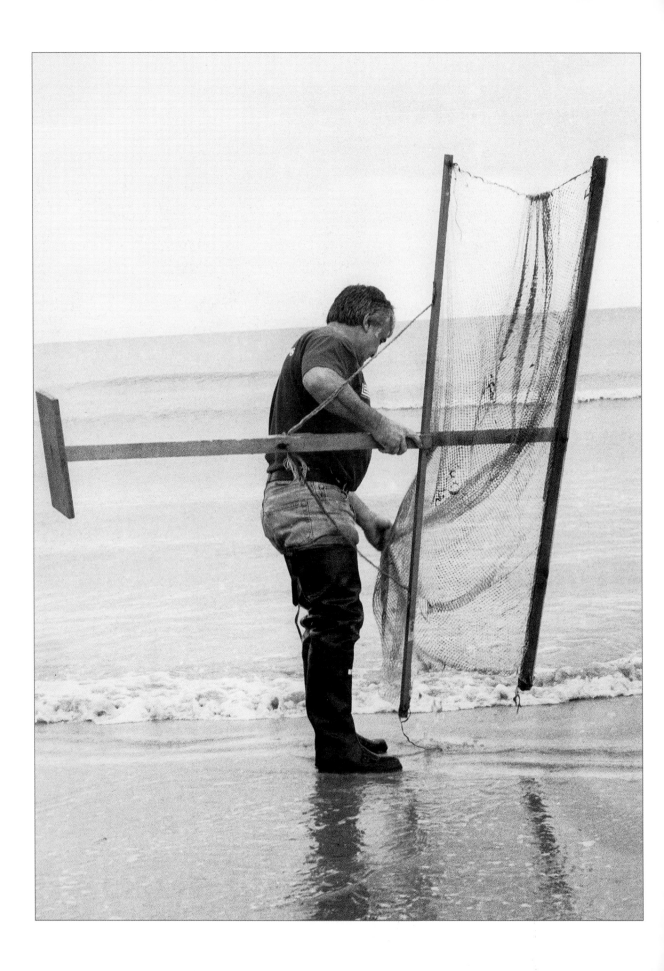

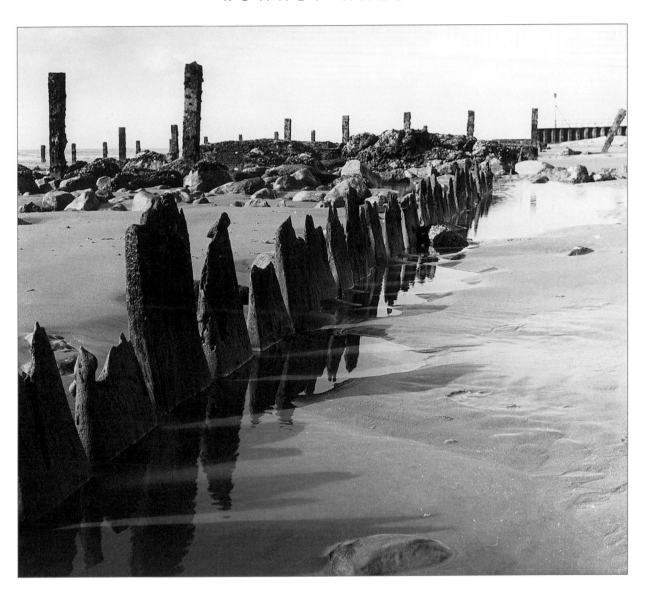

Here we see the remains of old sea defences at Dymchurch beach. Protection from inundation by the sea is an ongoing concern here, as Dymchurch lies 8 feet below sea level at high tide. On Christmas Eve 1999 the area was on red alert during a winter storm as strong winds combined with a very high tide and low pressure produced a dangerous storm surge that threatened to overtop the sea wall. Fortunately the wind direction changed and disaster was averted. Dymchurch beach featured in the cult TV series *The Prisoner* during the 1960s, starring Patrick McGoohan. In the opening scene, which was filmed here, the star was chased along a sandy beach by huge white rolling balloons.

Opposite: Shrimp fishermen at Dymchurch are a frequent sight trawling the sea's edge, as are bait diggers at very low tide by day or night. At one time tall fixed nets called kettlenets stood on the beach at Dymchurch. This unusual form of trapnet fishing was practised along the Romney Marsh coast by a couple of local families between the 1890s and the late 1950s.

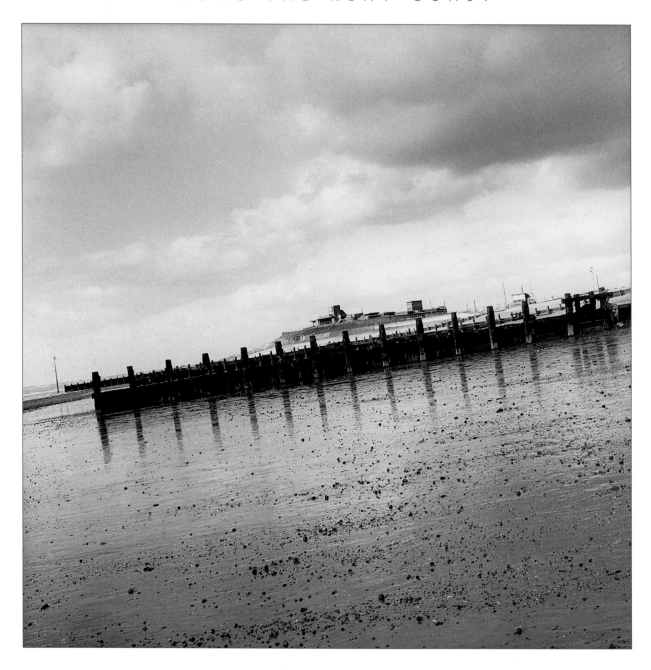

Beyond Dymchurch beach the Redoubt rises like an island above the sands. Originally this was built as part of Britain's line of defence against an expected invasion by Napoleon. The fort was of course never used for its original purpose, since Napoleon was defeated on the continent. Today it lies at the western end of the Hythe firing ranges and is used for troop training by the army.

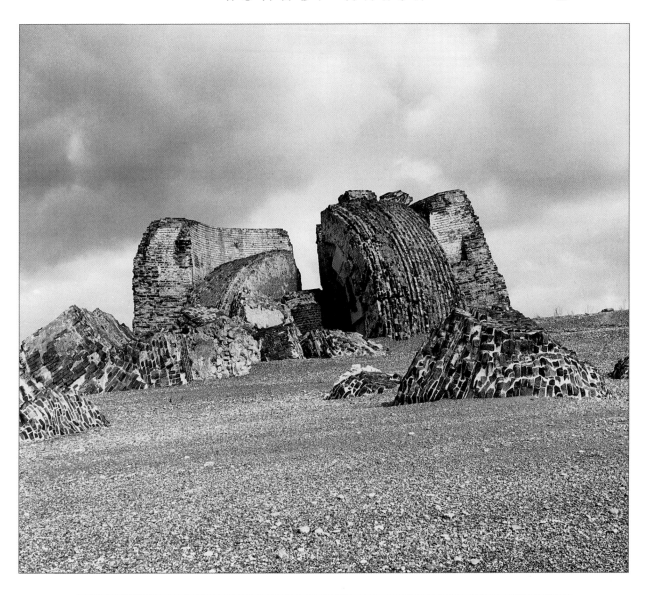

How are the mighty fallen! This is Martello Tower no. 19 (there were seventy-four built along the south coast between 1805 and 1812, as another defence against Napoleon), in its current ruinous state. In his *Rural Rides* William Cobbett describes the Martello towers as 'abominations' and decries the vast expense of unused defensive network. Built of at least half a million bricks and with walls up to 13 feet thick on their seaward sides, these little forts are not easy to demolish. In 1956 no. 23, situated on the A259 just outside Dymchurch, was the subject of repeated attempts at demolition for the purposes of road widening. High explosives were used twice to no avail, so the army was called in. Their first attempt succeeded in demolishing half the tower; a second dispatched the rest of it, but across the road, which was subsequently blocked for two weeks. What man finds difficult, nature handles with ease. Tower no. 19 fell foul of the erosive force of the sea in 1975. The remains lie on the unfrequented stretch of coast between the Dymchurch Redoubt and Hythe. Walking here is only safe when the firing range to landward is not in use, which is hardly ever.

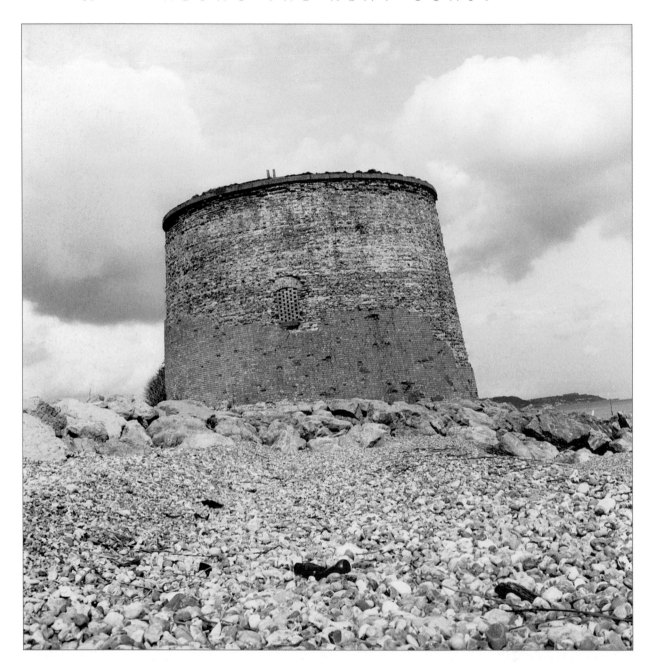

Further along towards Hythe, some Martello towers are still standing betwixt firing range and sea, but only just! This is Tower no. 15, in a poor state of repair and leaning badly. Although listed by English Heritage as an historic 'building at risk', remedial work is not likely owing to the precarious position of the tower next to the range. Other Martellos in better locations have been converted into very attractive, if unusual, homes. Some at Sandgate near Hythe were recently offered for sale by the Ministry of Defence for bids over £1. However, any potential buyer had to show they could spend at least £150,000 bringing the building up to standard. Martello Towers nos 3 at East Cliff, Folkestone, and 24 at Dymchurch are open to the public.

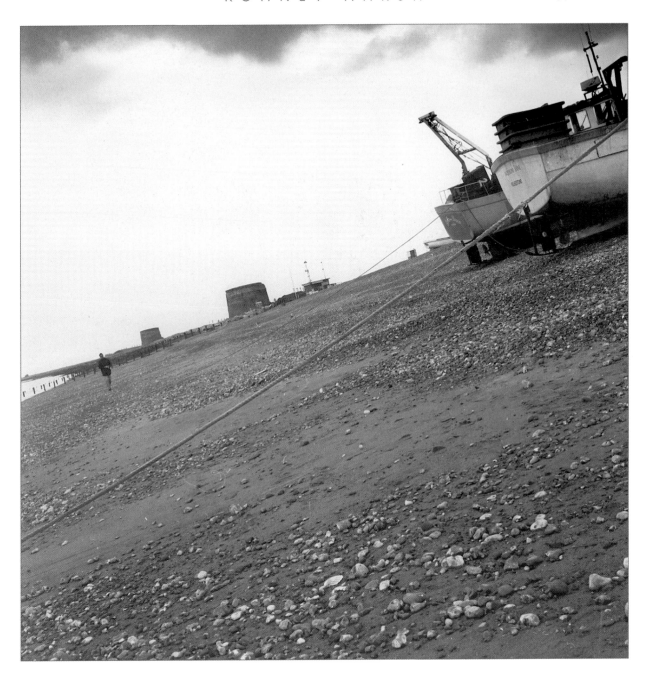

Looking back towards Romney Marsh from Fisherman's Beach at Hythe. Martello Towers nos 14 and 15 are visible in the distance.

Above and the following three pages: Sandgate beach in various moods: lone eccentric frivolity, calm and sunny, a winter storm and rock pools at low tide. Sandgate itself is well known for its antique shops and its authors. H.G. Wells lived here from 1898 to 1909, and described in his autobiography the sea spray splashing right over his first local home, Beach Cottage. Despite this he found 'Sandgate, along with Folkestone, the most agreeable place I have ever lived in'. Jocelyn Brooke wrote *The Military Orchid* and *The Goose Cathedral* while at Sandgate and has liberally spread descriptions of the locality throughout his books. Today Sandgate is the home of Reginald Turnhill, who writes on aviation and space and covered the Apollo moon landings for the BBC during the late 1960s and early 1970s.

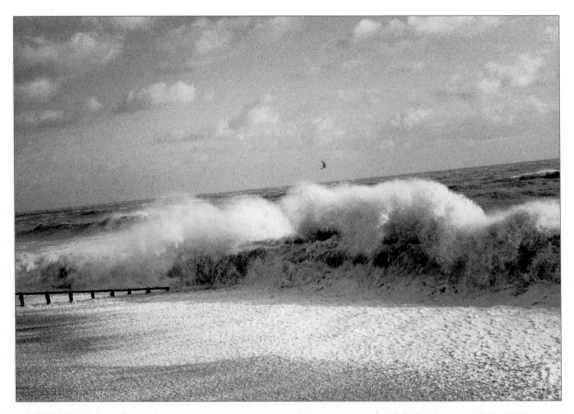

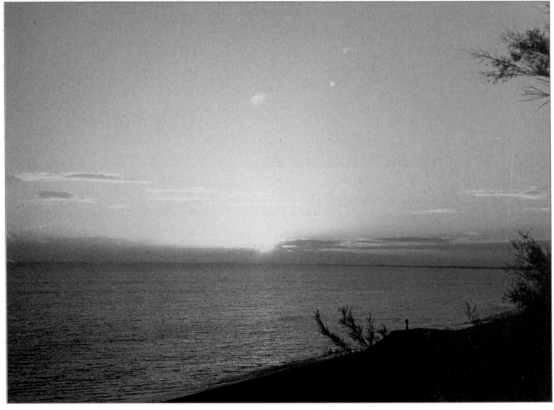

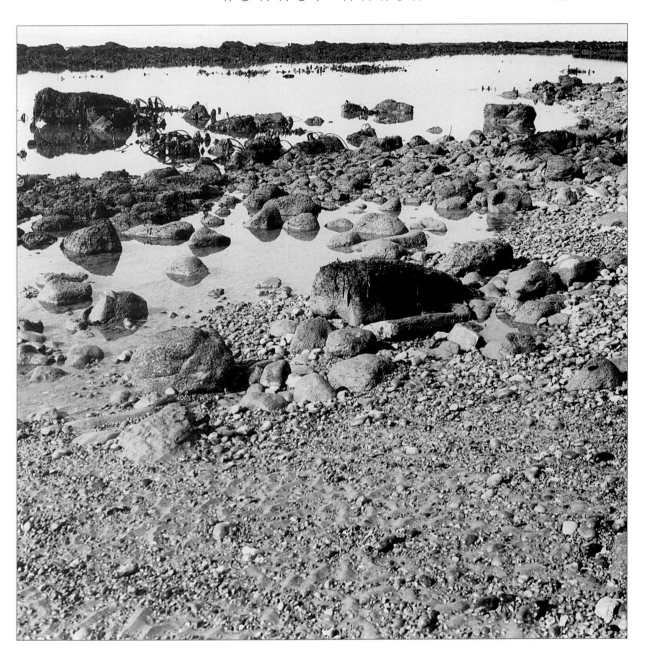

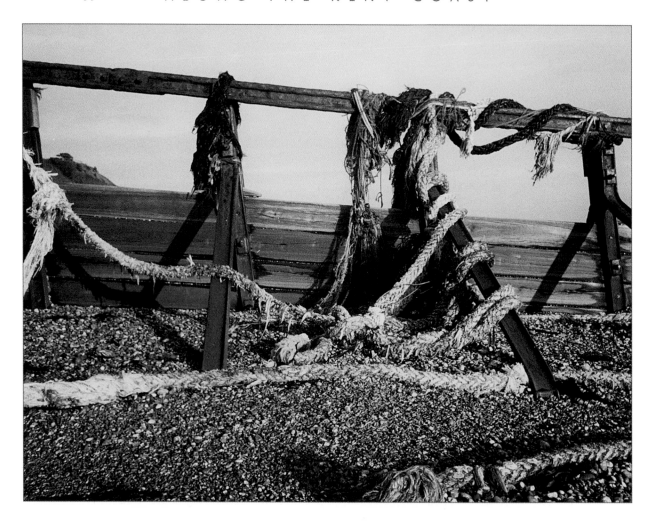

Sandgate beach after a rough night, with rope entangled around a groyne like some huge sea snake. This particular beach was the setting for the arrival of a mermaid in H.G. Wells's novel *The Sea Lady*, published in 1902. In the short time between taking this picture and writing this book, the image had already become dated. Beach replenishment for sea defensive purposes has resulted in these groynes being buried under tons of shingle, raising the level of the beach by many feet.

THE WHITE CLIFF COAST

Britain's 'bulwark coast', internationally known by virtue of the famous White Cliffs of Dover, has always been the country's first line of defence against foreign incursion. The impressive walls of chalk that greet arrivals to our shores are perhaps the best-loved natural feature of the British landscape. This is also among the most historically significant stretches of coastline in the country, and so is dotted at regular intervals with castles, pillboxes, gun emplacements and Martello towers. It has stood firm against successive waves of invaders or would-be invaders – Romans, Jutes, Vikings, Normans, French and Germans – and everywhere the evidence is easy to see. This coast exudes history, from the spectacular Dover Castle to the Bronze Age boat display in Dover Museum, from the Dover Patrol monument at St Margaret's Bay to the abandoned sound mirror on Abbot's Cliff.

It's not all cliffs and castles though. Folkestone, for instance, retains its Edwardian elegance, despite modern developments, in its fine clifftop hotels, ornate bandstand and popular waterlifts. Wooded garden landscapes line the sea front and the wild green undercliff of the Warren tumbles towards Dover. The bustling port of Dover, one of the busiest in the world, contrasts with the quiet streets and alleyways of Deal, an old and salty town once much frequented by smugglers and seamen.

Together these widely different towns and the spectacular cliffs between them make this coastline one of the most interesting to explore not just in Kent but in Britain as a whole.

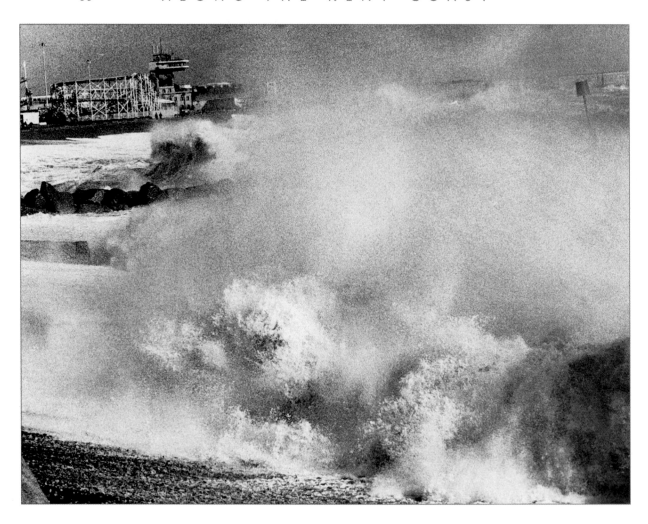

An angry and boiling sea in one of the worst storms for years. Folkestone sea front, November 2002.

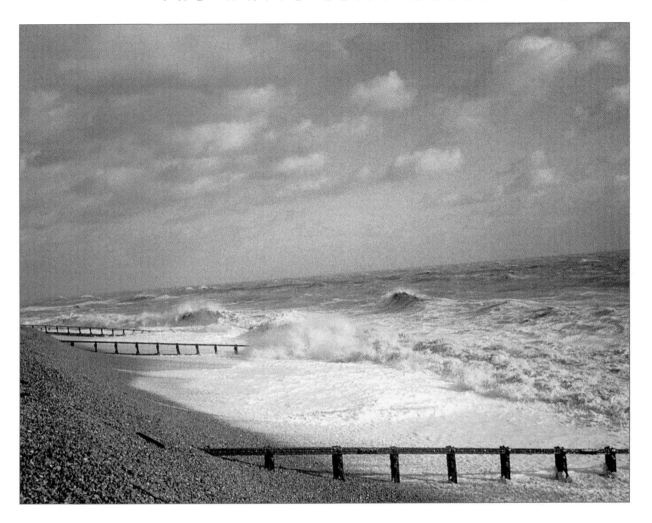

The storm abates.

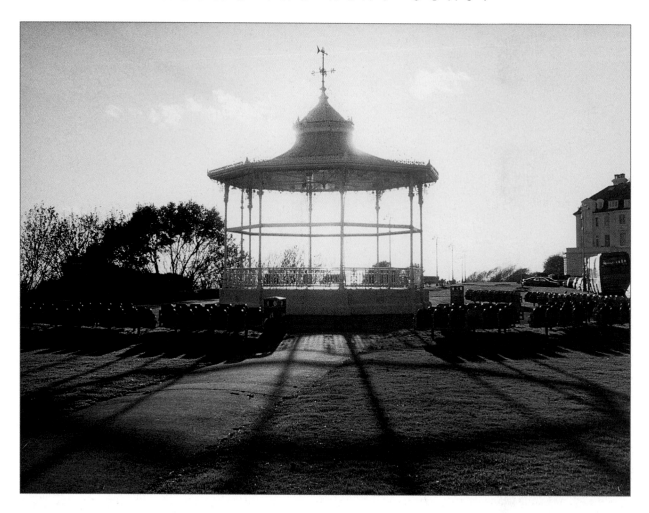

Above and opposite: The Victorian bandstand on the clifftop promenade known as the Leas, Folkestone. The last remaining of three, this ornate, well-maintained structure was originally built in 1885. During the summer months the bandstand hosts a range of musical entertainments. During the early years of the twentieth century the Leas was very much the place to be seen in fashionable Folkestone. Society ladies and gentlemen would promenade here in their Sunday best, some hoping to get a glimpse of Edward VII, who frequently stayed in The Grand, not far from here. The Leas features in H.G. Wells's popular novel, *Kipps*.

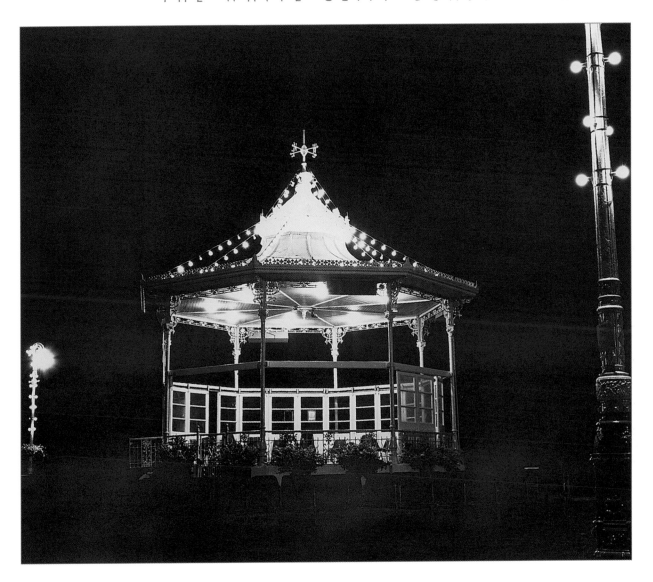

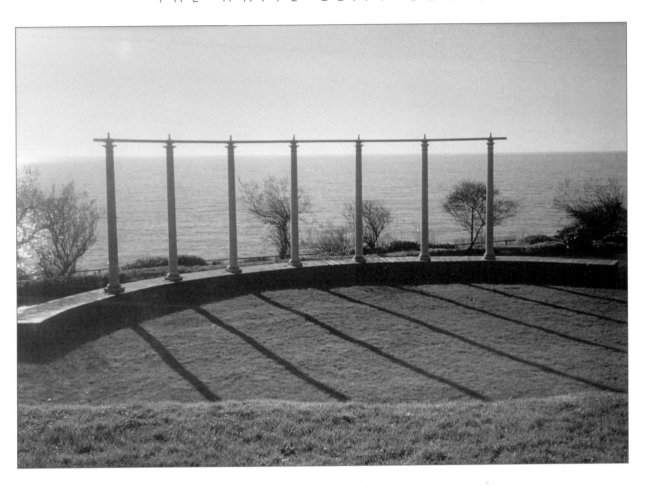

Next to the bandstand a zig-zag path leads down to the sea through artifically created caves to the amphitheatre below. This 350-seat grassed arena is a popular venue for all kinds of open-air performances played out against the changing moods of the sea behind. The amphitheatre is part of a newly created Coastal Park which contains the South-East's largest adventure playground, set in wonderful parkland beside the sea.

Opposite: Uncovered, or perhaps deposited, by a previous storm, an old anchor and a curious metal structure, part of who-knows-what.

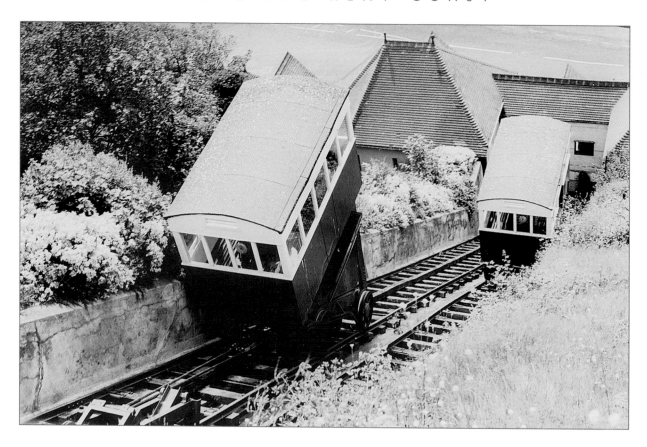

Above and opposite, top: The Leas lifts plying their way between the Leas and the Lower Sandgate Road are ever popular, especially among those going up! These water-powered lifts first opened in 1885 along with two others further along the Leas. They are said to be among Britain's oldest examples of this type of transport. It has been estimated that since opening, these lifts have carried more than 20 million people.

Opposite, below: The Coastal Park.

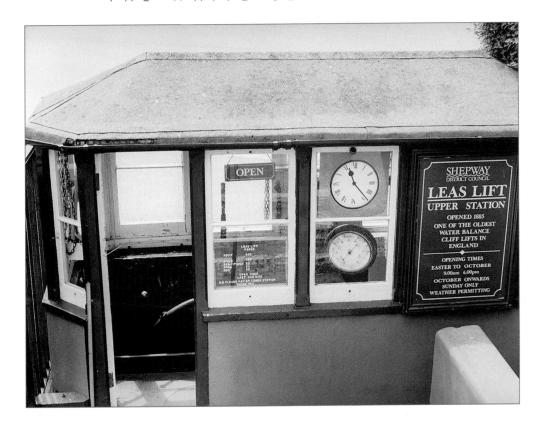

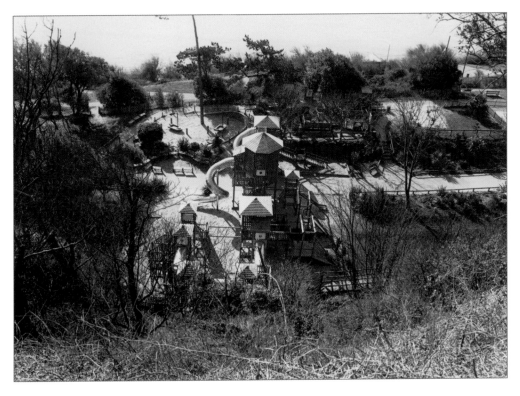

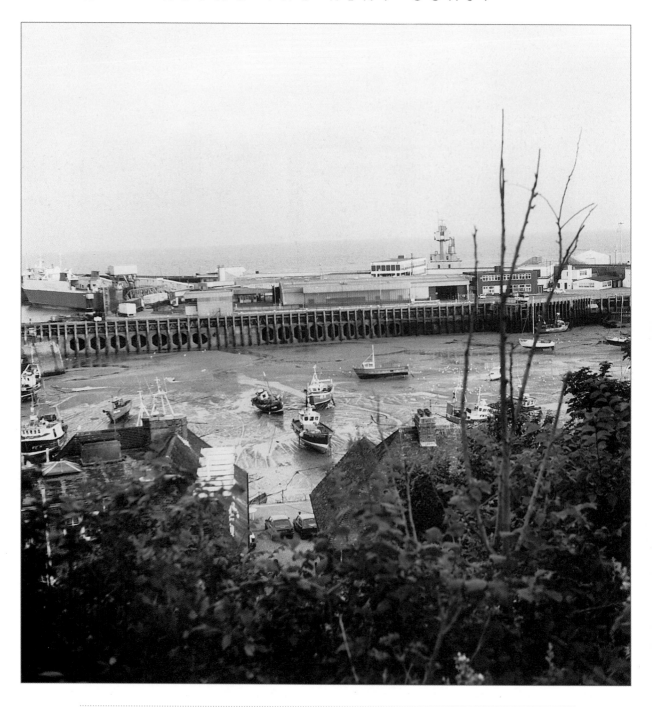

Folkestone Harbour at low tide, seen from the East Cliff. A freight ferry is docked – a sight no longer seen since all ferry services to the continent from here have now ceased. Near the horizon towards the right of the picture the oddly shaped tower, also seen in the first picture of this chapter, is a former observation and communications tower operated by Trinity House. It is now disused. There are considerable development plans afoot for this harbour in coming years.

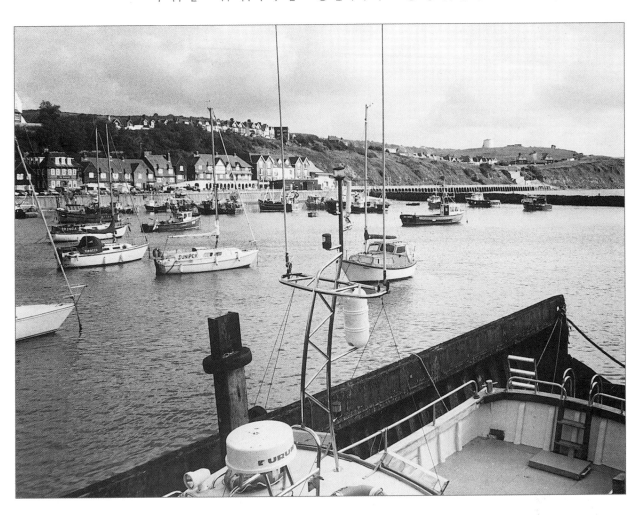

Another view across Folkestone Harbour to the East Cliff beyond. Towards the right of the picture a white-painted Martello tower can be seen atop the cliff. This is currently a visitor centre, containing displays detailing the history of the tower, and offers wonderful views from the top. Below the Martello tower a line of archways can be seen at the beach known as the Sunny Sands. These arches act as sheltered changing areas for swimmers on the beach.

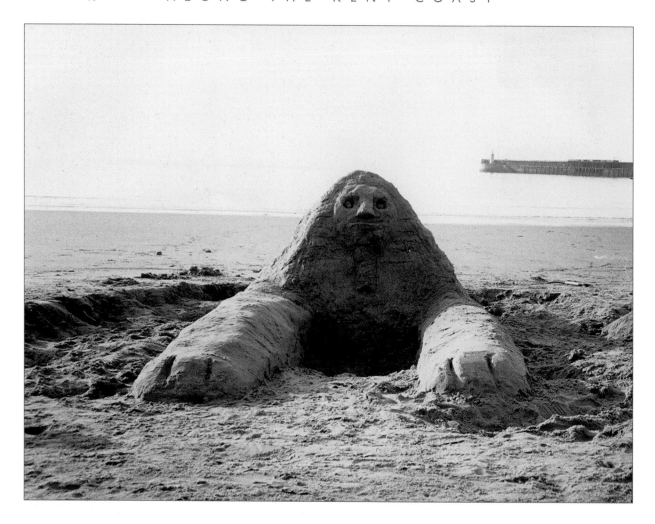

Down on the Sunny Sands, with the harbour wall behind, I came across a curious sand sculpture. This sphinx was created on 15 August 2002 by the Ingelbrecht family. In all, some ten people worked on the sculpture which ended up 16 feet long and 5 feet high. They started, under the direction of Karen Ingelbrecht, a sand tutor, at about 5 a.m. as the tide was going out and by 7.30 a.m. they had finished. The sculpture survived until the returning tide flattened it at about 3 p.m.

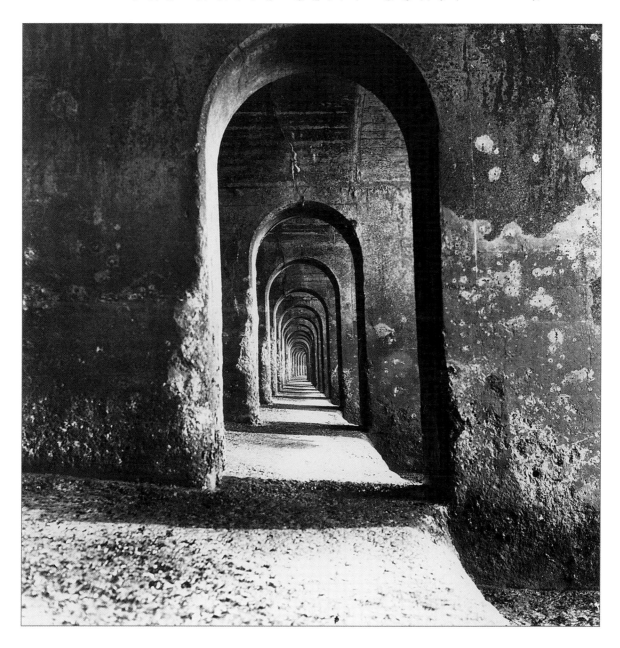

Not some vast underground hall of a Tolkienesque mountain king, but the arches at Sunny Sands seen from within. This 'tunnel' runs the length of the sea wall, known as Coronation Parade, and provides great fun for children running along dodging the incoming sea. I know, I've done it – many years ago!

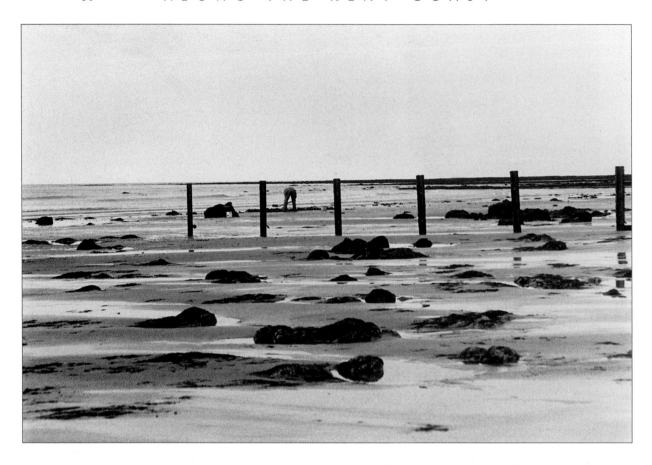

Above and opposite: The beach at East Wear Bay below the Warren, a unique area of tumbled undercliff caused by successive landslips and a paradise for naturalists and fossil hunters. Here we see East Wear Bay in two moods: early-morning calm as bait diggers take advantage of an empty beach at low tide, and the return of the tide with a vengeance, to cause more erosion to the unprotected cliffs behind this unspoiled bay. This erosion has been a blessing in disguise since it continually reveals fossils and archaeological remains from the Iron Age and Roman periods as well as from more recent times. Abbot's Cliff can be seen across the turbulent seas of the bay.

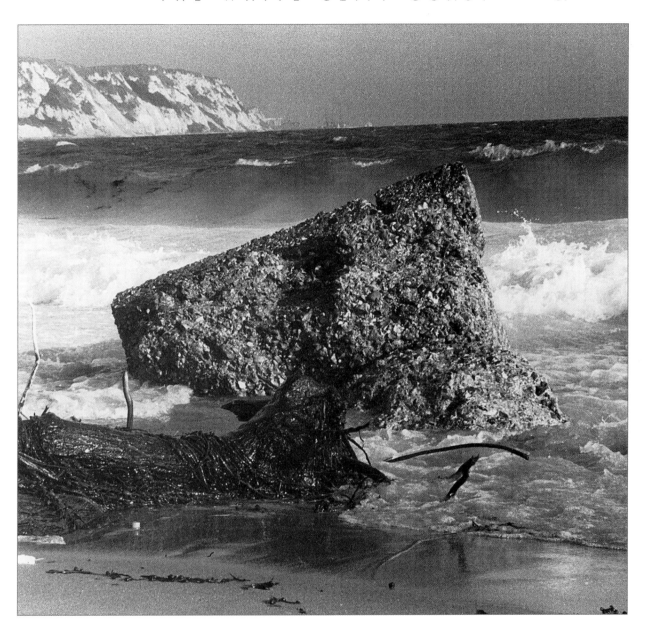

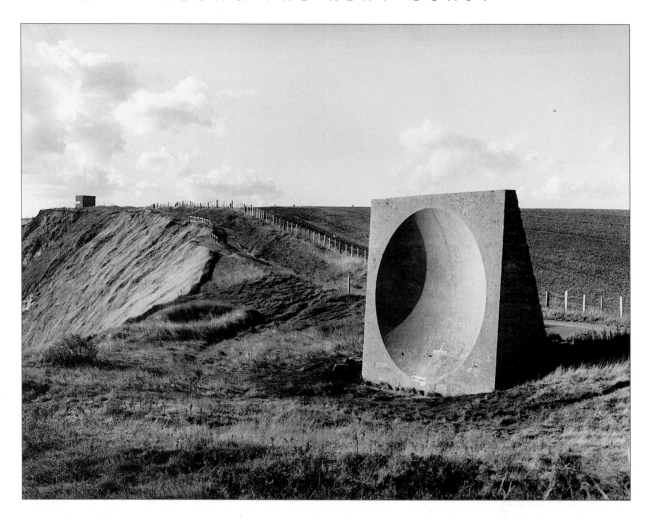

This curious structure on top of Abbot's Cliff is not the megalithic satellite dish it may appear but something of more recent vintage – a 1930s pre-radar brainwave, or 'sound mirror', essentially a big ear listening for the sound of enemy aircraft taking off across the Channel. A number of such 'ears' were built along the south-east coast but, as with so many military constructions, were never used. Plans are afoot to build two working versions, one at the Coastal Park in Folkestone, and one near Calais, in France. These would allow people at either end to speak to one another via the mirrors as a demonstration of the wonders of acoustics.

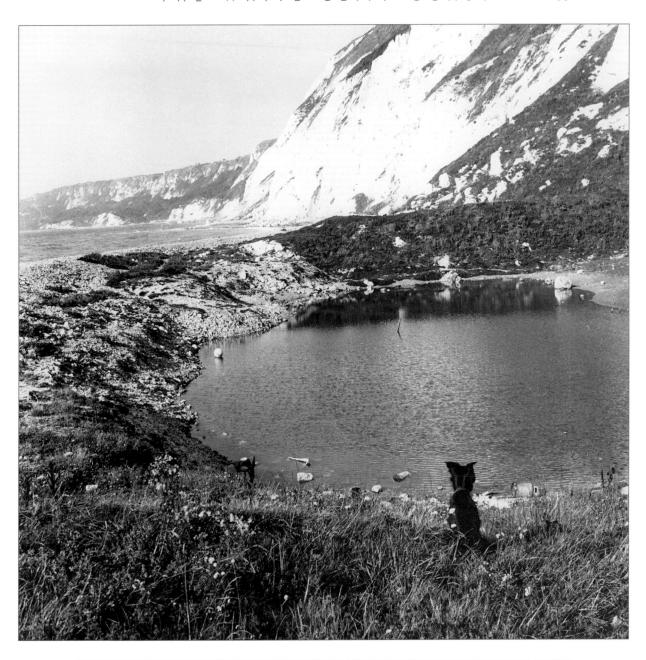

Below Abbot's Cliff a spring known as Lydden Spout feeds this eternal pond on the shore. Unremarkable you may think, but it has a sinister reputation, for it has earned the name Dead Man's Pool. Apparently whenever someone falls overboard, is believed drowned or goes missing along this stretch of water it is here the Coastguard usually check first because the interplay of currents brings much ashore at this point. Leaving aside the area's gruesome reputation, the flotsam and jetsam to be found here make it a paradise for beachcombers. The shore here is also well known for sea kale, a form of salt-loving cabbage, apparently quite bitter to the taste but said to be the ancestor of modern species of the vegetable. This remote shoreline is unofficially popular among local nudists.

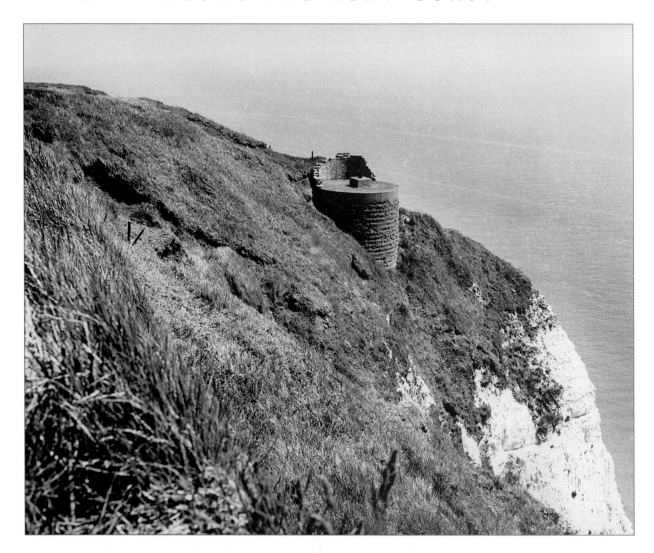

Above and the following two pages: Second World War gun emplacements perched precipitously between Abbot's and Shakespeare's Cliffs near Dover. No less a part of our history than more ancient fortifications, these precariously placed structures are ever more threatened by the inexorable landward advance of the cliff edge. For some it is too late, and their remains already lie scattered on the beach below.

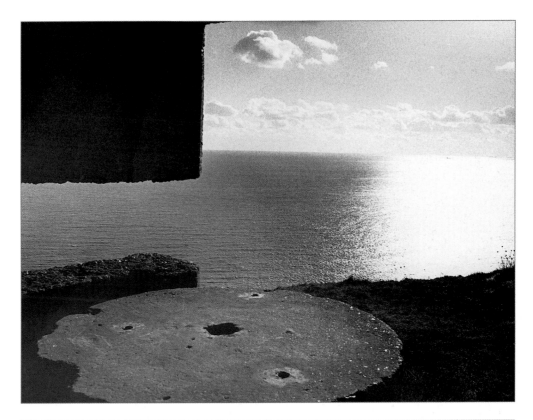

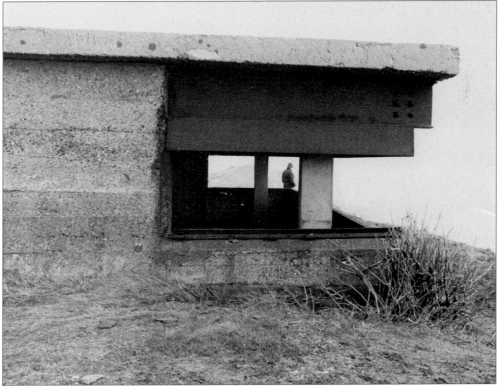

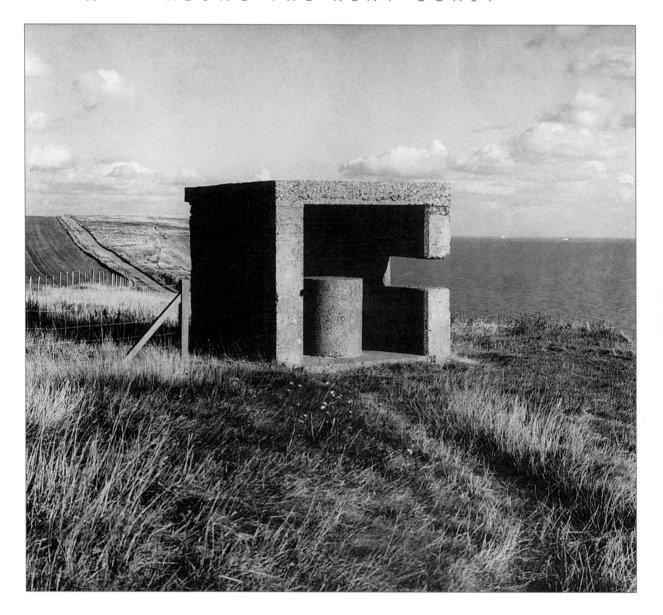

Keep Out! Actually you wouldn't want to pass this fence or climb over it as there is a sheer drop of over 500 feet on the other side. In recent years the North Downs Way and the Saxon Shore Way, both long-distance footpaths, have been re-routed inland owing to the increasing instability of the cliff edge.

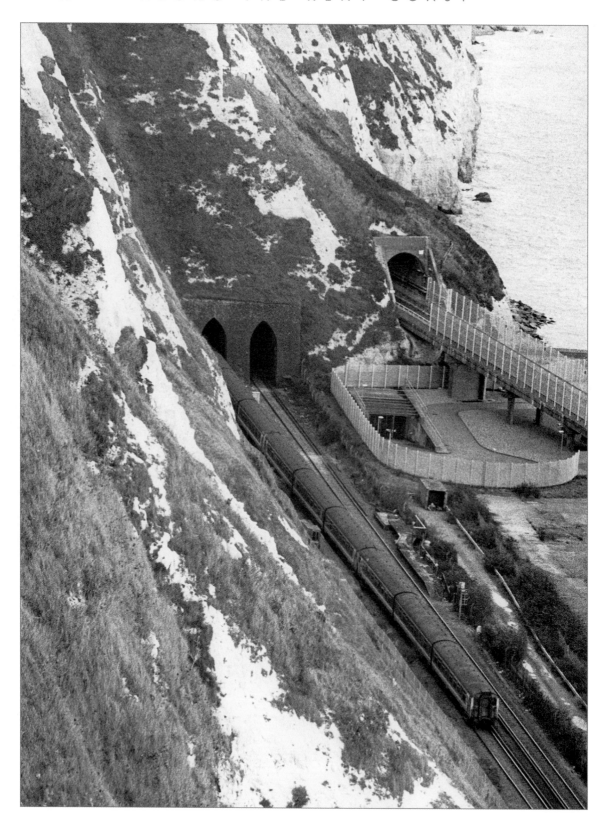

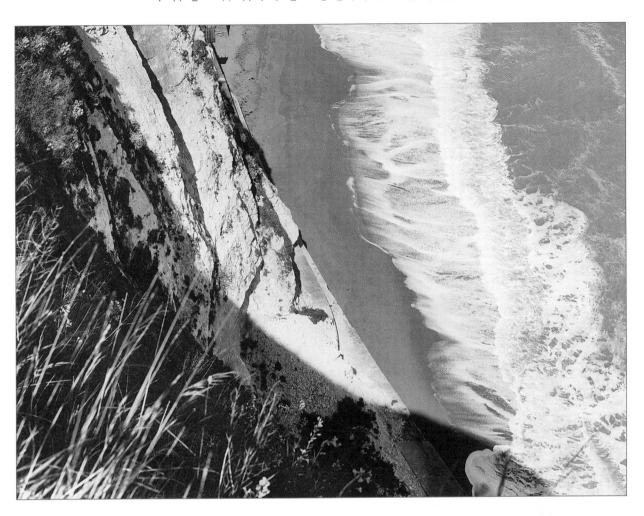

Don't try this yourself! A vertical shot 300 feet down from the top of Shakespeare Cliff to the wave-washed beach below. Shakespeare Cliff is named after the famous bard because of his mentioning this particular spot in *King Lear*, where he refers to the samphire-gatherers hanging halfway down. 'Dreadful trade', his character observes. You can say that again!

Opposite: The most expensive railway line in the country by virtue of the constant monitoring and maintenance needed owing to the ever-present threat of landslips. Stretching beneath the cliffs between Folkestone and Dover, this line has been closed several times as a result of massive cliff movements and chalk falls. The other opening in the cliff, next to the rail tunnels seen here, is where the access road for Channel Tunnel construction workers came out at the project's site. This is now a nature reserve open to the public.

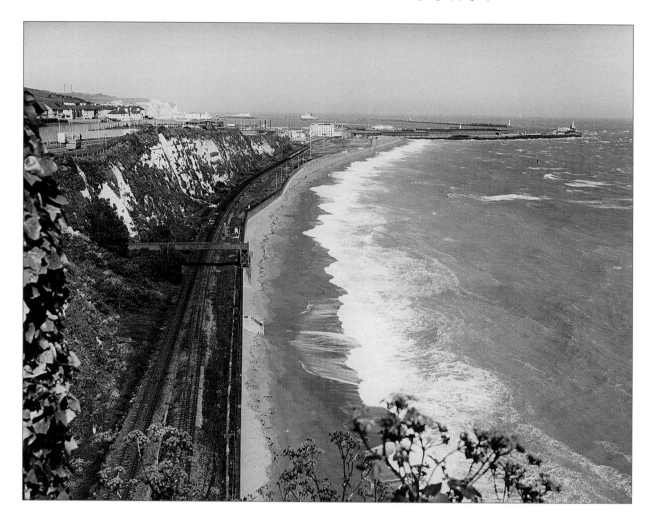

Approaching Dover, looking along the railway line as it runs parallel with the beach towards the harbour, the busiest ferry port in the world and now a cruise terminal too. Incidentally, the harbour complex can be seen clearly from space.

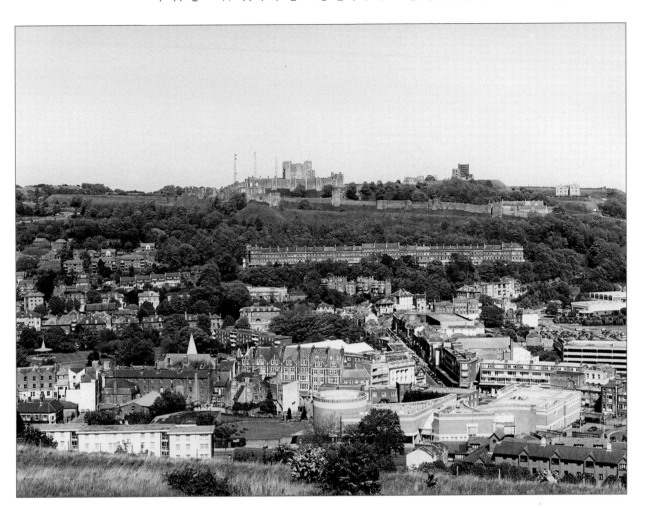

Looking from the hills to the west, known as the Western Heights, across Dover to the famous medieval castle built by Henry II. Known as the 'key to England', Dover Castle is one of the finest fortified buildings in Britain and is well worth a visit. As well as medieval fortifications there is a Roman pharos (lighthouse), a Saxon church and underground tunnels built in the late nineteenth century and reused in the Second World War. It was from here in 1940 that 'Operation Dynamo', the plan to evacuate the British Army from Dunkirk, was masterminded by Vice-Admiral Ramsay and Sir Winston Churchill. The tunnels were extended during the Cold War to form a nuclear bomb-proof regional seat of government. The circular building in the foreground, which formerly contained a historical display entitled 'The White Cliffs Experience', has now closed. Next to this is an excellent museum housing an informative and atmospheric display of a Bronze Age ocean-going boat, kept in a remarkable state of preservation.

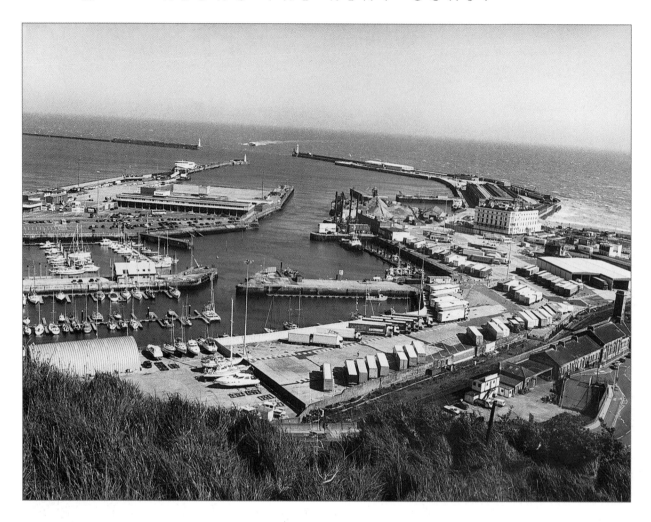

Dover makes its living as a thriving port. At any one time up to six vessels coming into or leaving port can be seen from the cliffs above. Not only are there big new super-ferries but also catamarans and cruise ships, which now depart from Western Docks. Formerly hydrofoil and hovercraft constantly came and went from here. This view also shows the yachting marina at De Bradelei Wharf, which additionally contains a modern factory shop development. The white square building near the right of the view is the former customs building known as Southern House. A catamaran can be seen entering the harbour in the distance, while another is visible docked against the middle pier.

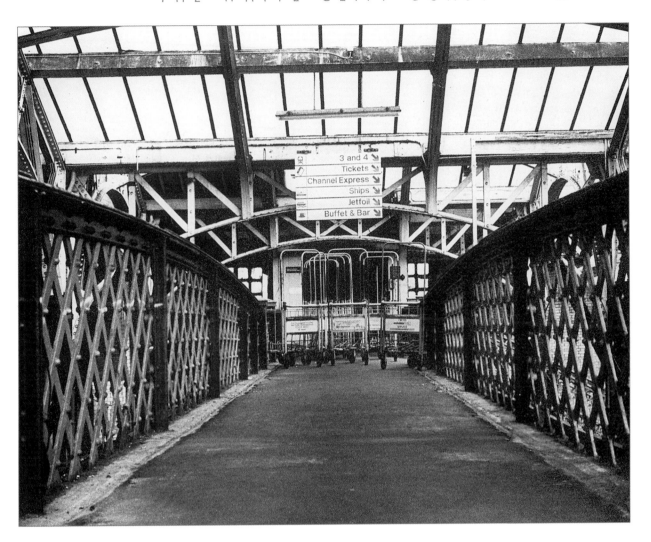

3 and 4
Tickets
Channel Express
Ships
Jetfoil
Buffet & Bar

Dover Marine station. These are some of the last shots taken before it closed to make way for a cruise ship terminal. Trolleys stand abandoned on a footbridge beneath redundant signs. The 'jetfoil' referred to was a hydrofoil that ran between Dover and Ostend, a service until recently operated by Hoverspeed using modern catamarans.

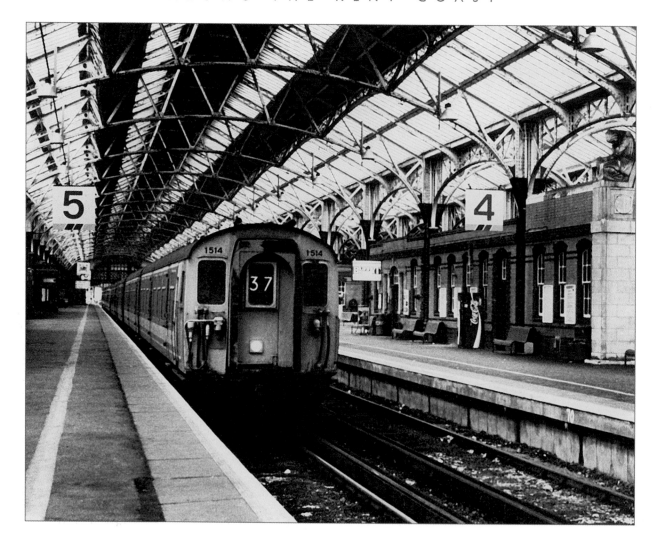

Almost the last train to arrive at platform 5, Dover Marine station. The Marine station exclusively serviced the docks. Dover continues to have a main line railway station in the town, known as Dover Priory station.

A lazy day on Dover sea front. Beyond the pier can be seen the propellers and fins of a number of SRN4 hovercraft. These successfully took large numbers of cars and foot passengers across the Channel for over thirty years, but they were costly to operate and very noisy. The last SRN4 completed its final journey late in 1999. Hoverspeed now run fast and much quieter catamaran services to the continent.

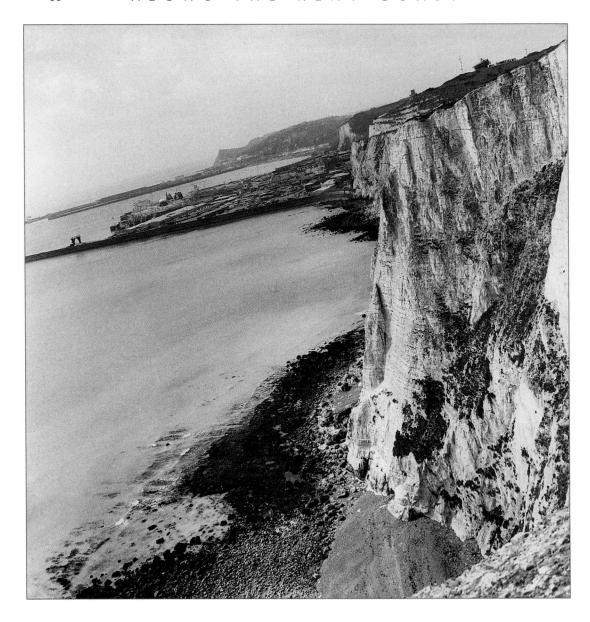

Looking west from Langdon Cliffs towards Dover Harbour. The angular formation in the distance is Shakespeare Cliff. On the horizon to the right can be seen the Anglo-Saxon church within Dover Castle's precincts and the Coastguard station. Looking at the cliffs themselves it's interesting to reflect on the fact that they are composed of billions of microscopic sea creatures called cocoliths. These were laid down and compacted over many millions of years until uplifted to form the cliffs we see today. At Langdon Cliffs there is a fascinating new interpretation centre and refreshment stop set up jointly by the National Trust and the local holiday and insurance company, Saga.

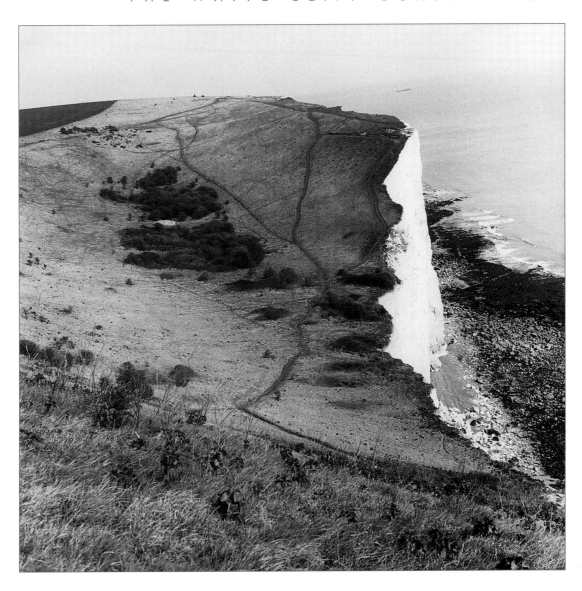

A quintessential view of the English Channel coast: the White Cliffs of Dover, here seen at Fan Bay halfway between Dover and St Margaret's Bay. Being at the point of England closest to the continent these cliffs have been heavily defended over the years. Many of the wartime pillboxes and bunkers have been demolished but as recently as the 1970s it was possible to see many such structures, empty and forlorn, littering the cliff tops. As a boy I and my friends explored several of these, some of which were connected by underground tunnels. One such bunker contained a flight of steps that zig-zagged down 150 feet or so below the ground and emerged out of a small obscured opening in a valley like this one elsewhere on these cliffs. Ah, the perilous adventures of youth! Thankfully all these openings are now well and truly filled in. Despite the proximity of the busy ferry terminal at Dover Harbour, the breezy downland cliff tops between Dover and Kingsdown are one of the most tranquil parts of the Kent coast. Skylarks can still be heard twittering overhead and Exmoor ponies graze contentedly as distant walkers meander across this Hardyesque landscape.

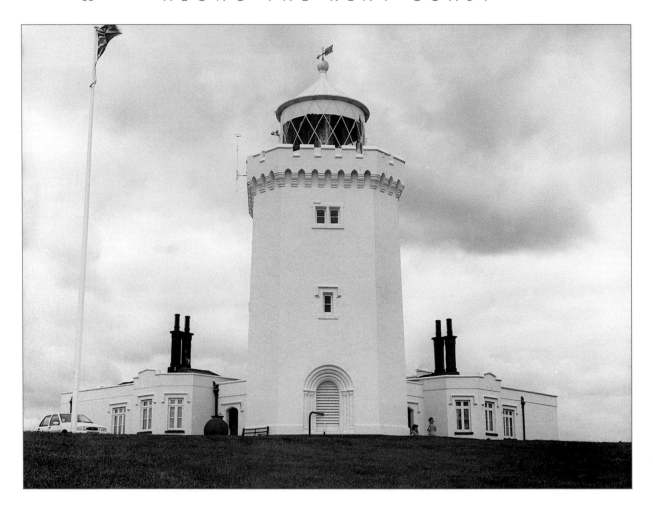

The South Foreland Lighthouse near St Margaret's Bay, between Dover and Deal. From this attractive tower Marconi conducted the first successful ship-to-shore radio experiments in 1898, followed a year later by the first radio transmission across the Channel. A popular walk runs from the National Trust/Saga Gateway Centre at Langdon Cliffs to this lighthouse and back. In the summer months the tower is open to the public. The adjacent cottages are available to rent as holiday homes.

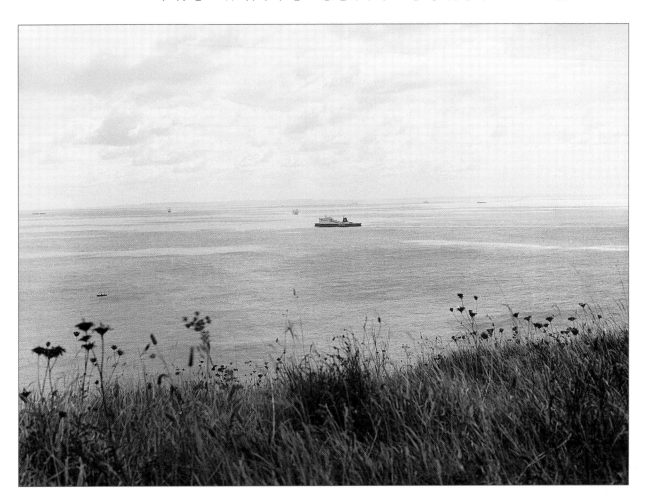

Across the ferry-filled waters of the Straits of Dover lies France, visible in this view from South Foreland
near the lighthouse. Note the number of vessels on the far horizon.

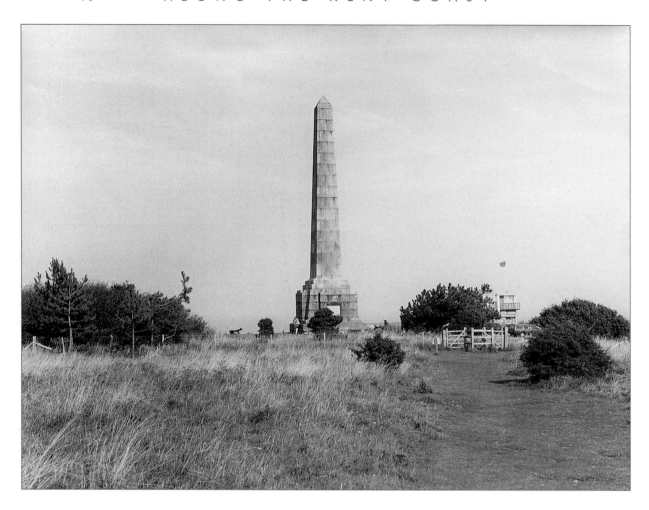

This impressive obelisk stands on the cliffs to the north-east of St Margaret's Bay. It commemorates the work of the Dover Patrol, which patrolled and protected these shores and the adjacent sea lanes during the First World War. The small building behind the bushes with a union flag flying is an old Coastguard station, now converted to a café. The cliffs and downs from here to nearby Kingsdown feature in Ian Fleming's James Bond adventure, *Moonraker*. In the original book version of the story a rocket base exists around here, the launch of Moonraker taking place from these cliffs. Perhaps Fleming, who rented a house in St Margaret's Bay for a while, was inspired by the monument.

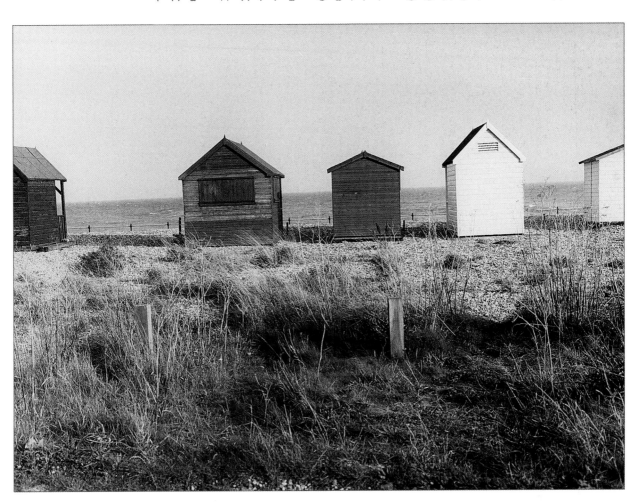

Beach huts at Kingsdown. Always a popular form of holiday accommodation, these huts increasingly fetch surprisingly high prices. The beach here is a wide shingle expanse, empty in winter and not much frequented in summer either. It was here, at the end of the line of white cliffs, that Julius Caesar landed on our shores in 55 BC – or so it is claimed.

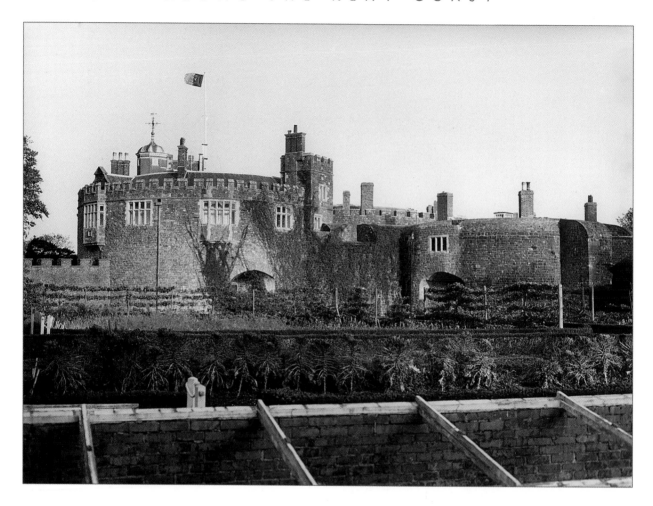

Above and opposite, top: Walmer Castle, one of several fortifications built by order of Henry VIII to defend the coast against an expected invasion from the continent by forces loyal to the Pope. The castles all have a layout that, seen from above, resembles a rose, the Tudor rose of course. The others in the series are at Camber, Sandgate, Deal (*opposite, bottom*) and Sandown. Walmer Castle is surrounded by attractive gardens, which, along with the stately interior of the castle itself, are open to the public. The property is managed by English Heritage and a regular series of events is held in the grounds. The castle is the official residence of the Lord Warden of the Cinque Ports. The most famous holders of this ancient title are undoubtedly the Duke of Wellington and the late Queen Elizabeth the Queen Mother.

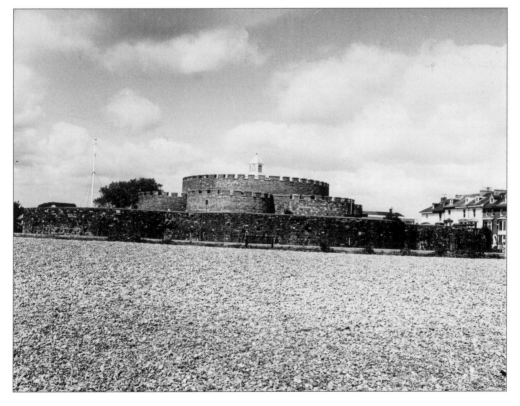

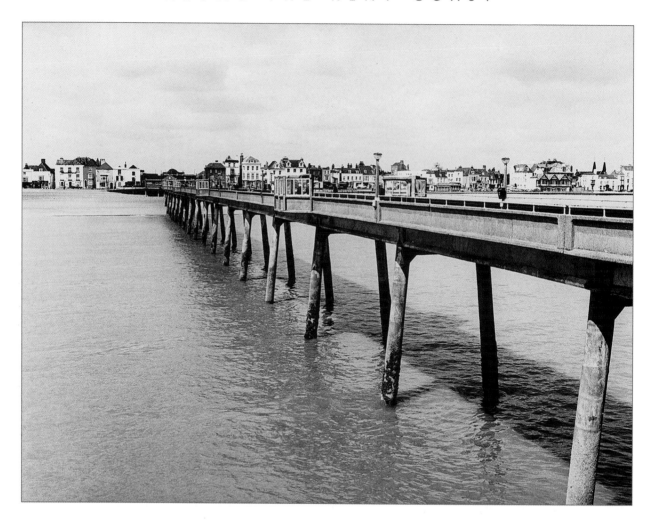

Above and opposite: Two views of Deal Pier. Opened in 1957, this is the most recently built pier around the coast of Britain. It replaced an earlier pier demolished when a ship collided with it in 1940. During the late 1950s and early 1960s steamers called at the end on a regular basis to take on passengers. Today it is used more as a pleasant marine walk with perhaps a hearty breakfast in Goodwin's Restaurant at the pier's end. The access to deep water afforded by Deal Pier makes it very popular with sea anglers all the year round, but particularly during the regular fishing competitions held here.

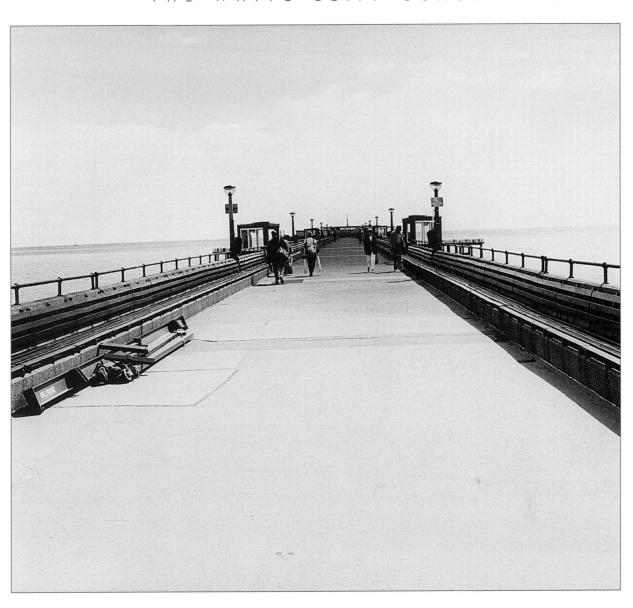

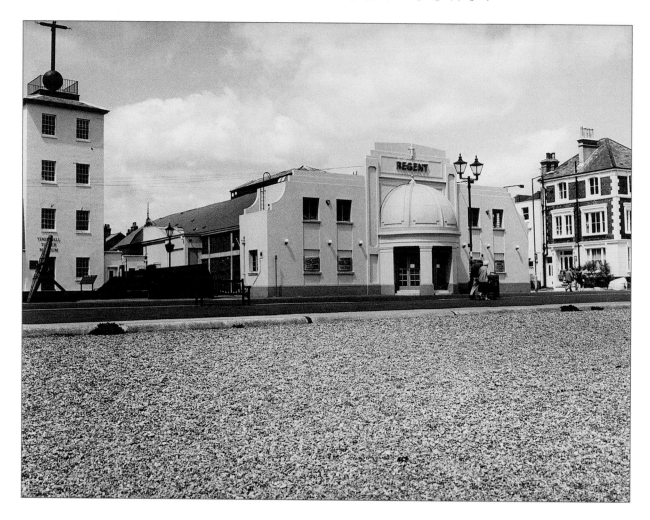

Part of Deal sea front. There are two interesting buildings in this view. In the centre of the picture stands the Regent, once a cinema but now a bingo hall with its attractive dome-roofed foyer. At the far left can be seen a tall three-storey building topped by a cross-shaped structure with a black ball at its base. This is the Timeball Tower. Originally the tower was a signalling station that used semaphore signals to convey messages to and from the Admiralty at Greenwich. At the time of the anticipated invasion by Napoleon a signal could be passed along the chain within two minutes. Later, in 1853, the signalling station was converted to use the timeball which dropped down the mast at 1 p.m. each day to allow shipping out at sea to set their chronometers accurately. The correct time was conveyed to Deal from a similar time ball mounted in Greenwich. With the line of connecting semaphore stations fully manned, it was estimated that Deal's timeball was only half a second behind that of Greenwich. Apparently the black-painted copper ball was raised halfway up its mast at 12.55 p.m. each day. By 12.58 p.m. it had reached the top and at 1 p.m. sharp it was dropped. The timeball apparatus was dismantled in 1927 and the tower in recent years functioned as a museum of telegraphy, though currently it is closed.

AROUND THANET

The isle of Thanet is an isle no longer, since the Wantsum Channel that once separated it from the mainland has completely silted up. This is just one of the changes that time has wrought on this crowded corner of Kent.

Thanet has played a major part in the history of Britain. Successive invaders and colonisers made Thanet and its environs their initial base in Britain. In AD 43 the Romans made Richborough (near the present-day town of Sandwich) their first military outpost in this country.

Later, in the year 449 according to the *Anglo-Saxon Chronicle*, the first Jutes to arrive in Kent landed at Ebbsfleet, led by the semi-legendary Hengist and Horsa. Invited to Britain by the infamous Vortigern to aid him in fighting the Picts and also prevent a future Roman invasion, these able mercenaries went on to take over the whole of Kent and to found the first of the kingdoms that would later merge to become England.

Until 597 these kingdoms were pagan, but in that year St Augustine arrived from Rome bringing Christianity to the English and promoting the return of Roman culture to these shores. Augustine, who subsequently became the first Archbishop of Canterbury, landed at Ebbsfleet, as did Hengist and Horsa before him. A stone cross commemorates his visit.

Today Thanet is considered by most as the typical seaside holiday resort, with buckets and spades and golden beaches, Punch and Judy and donkey rides. Things are changing though, and all along this coast a process of rebranding is in progress in line with an age where people require more than candyfloss and funfair rides.

In this chapter we travel *around* Thanet, from the picturesque medieval town of Sandwich in the south of the island, through atmospheric Pegwell Bay to the seaside towns of Ramsgate, Broadstairs and Margate. Our journey passes sandy bays, striking chalk cliffs and superb Victorian architecture to reach the stark, lonely towers of Reculver and, beyond, the sedate resort of Herne Bay.

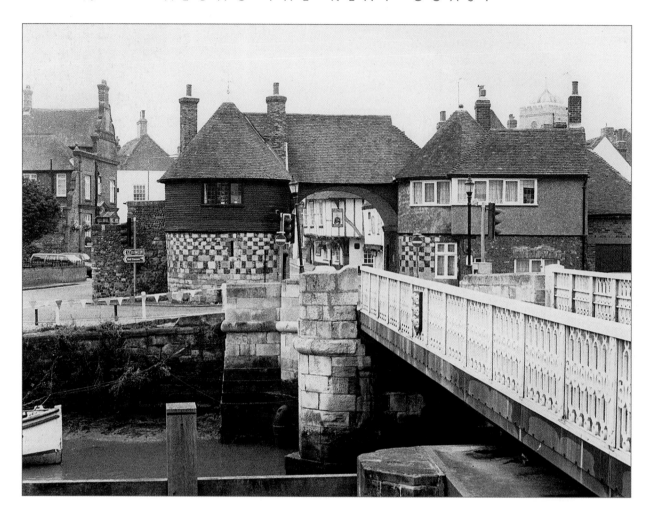

Sandwich. Once one of England's principal ports, it is now over a mile inland, though still with a functioning quayside owing to the presence of the River Stour. This view across the Stour shows the superb Barbican Gate, just one of the 400 or so historically valuable buildings of medieval vintage to be found in Sandwich.

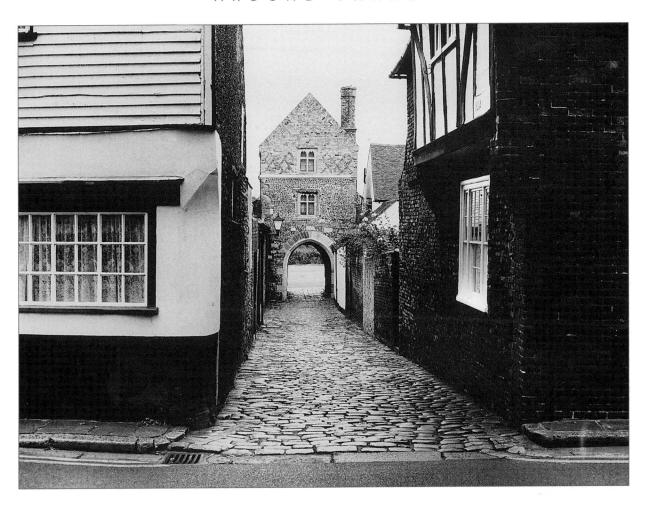

Quay Lane, Sandwich, looking towards Fishergate, a fine example of a surviving town gate. The gate's upper storey is of Elizabethan brickwork with diagonal patterns. The narrow lane is typical of this ancient town which is thronged with visitors most weekends. Periodically the town hosts the British Open Golf Championships, played on the nearby Royal St George's Golf Course.

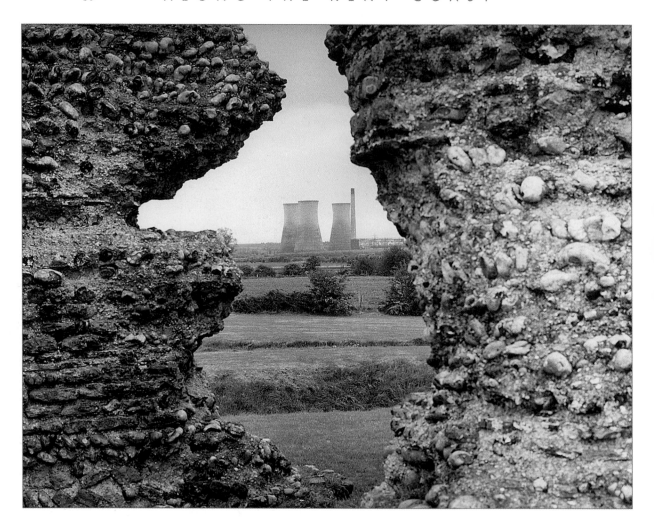

Ancient and Modern. Through a gap in the mighty walls of the Roman fort at Richborough can be seen
the cooling towers of a now defunct coal-fired power station. A windmill on the site still generates
electricity, apparently enough to power a small town. The Roman fort was established and developed
over a period of 350 years, and remained one of the most strategically important military outposts in
Britain during the Roman occupation. Visitors can wander around the empty ruins and learn more
about the history of this impressive site, which is run by English Heritage. Archaeological finds on the
site suggest the fort was occupied virtually continuously after the Romans departed, until the
establishment of the nearby town of Sandwich and the silting up of the Wantsum Channel made it
redundant.

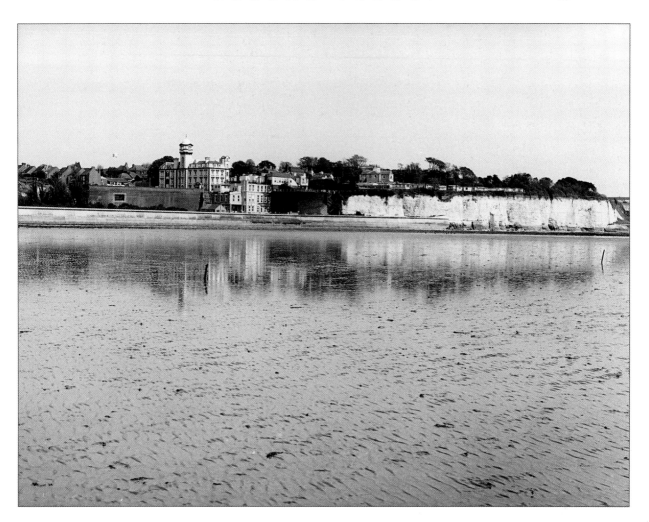

Pegwell Bay, expansive at low tide, is a paradise for bait diggers, ornithologists and walkers in search of solitude. Atmospheric the bay is certainly, but it is not remote. An accessible wilderness within easy reach of the old road between Sandwich and Ramsgate, Pegwell Bay is bounded by the outskirts of Ramsgate on one side and by the imposing 'pepperpots' of Richborough power station on the other.

The cliffs of Thanet, punctuated by caves, were once used by smugglers. The dark circular patches on the sands are areas of salt marsh cord grass, which provides food for the many wading birds that frequent this shore.

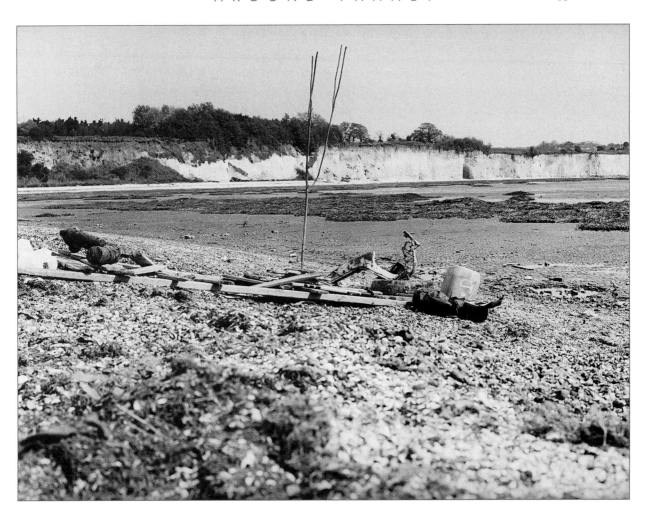

A home-made raft, abandoned or washed up. Where has it been, I wonder, and what adventures have its builders experienced? The coast here has seen more than the arrival of adventurous children. The Roman invasion led by Claudius in AD 43, the arrival of Hengist and Horsa in 449 and St Augustine in 597 are just some of the important historical landings hereabouts. A realistic replica of a Viking ship named the *Hugin* is on display nearby. During the 1960s and 1970s vessels of a different kind operated here. Cross-Channel hovercraft services came and went for ten years or so until the service was concentrated in Dover. All Cross-Channel hovercraft have now been withdrawn and replaced by catamarans. Pegwell Bay meanwhile has returned to its former tranquil ambience.

In winter, when the visitors have gone, Ramsgate beach, like any resort, belongs once again to its local residents. Sad and empty, or time and room to breathe? It's all a matter of taste.

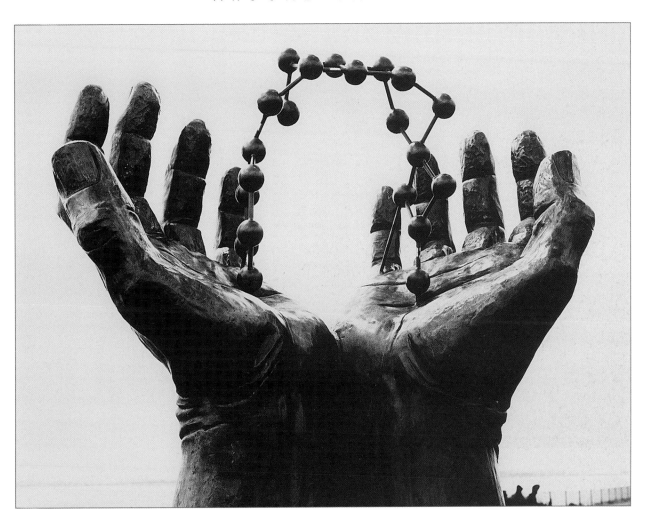

Hands and Molecule, an impressive sculpture in bronze by David Barnes, sited on Prince Edward Promenade at Westcliff, Ramsgate. This sculpture celebrates the discovery and development of innovative medicines in East Kent and was funded by the pharmaceutical company Pfizer, best known perhaps for their recent development of the anti-impotence drug Viagra. Commissioned by SUSTRANS, the sculpture acts as one of the markers on the National Cycle Network as it skirts this coast.

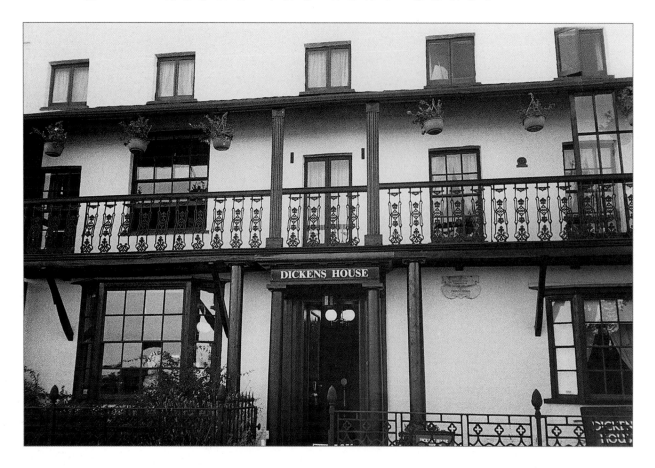

Above and opposite: Charles Dickens loved Broadstairs, at least until he made it too popular by his presence. His memory lives on in many forms – his frequent references in praise of the town, in fact and fiction, the annual Dickens Festival every June and the two museums that deal with his life and works. Dickens's House was the inspiration for Miss Betsy Trotwood's cottage in *David Copperfield* and is now a museum dedicated to Dickens's legacy. Bleak House, rising like a castle above the pretty little Viking Bay in Broadstairs, is also a museum. It deals with local maritime and smuggling history in addition to Dickens's life there. It was here, sitting in his study overlooking the sea, that the great author finished *David Copperfield*, and planned, as you might guess, *Bleak House*. Today Broadstairs remains an unpretentious resort providing a tasteful ambience and entertainments.

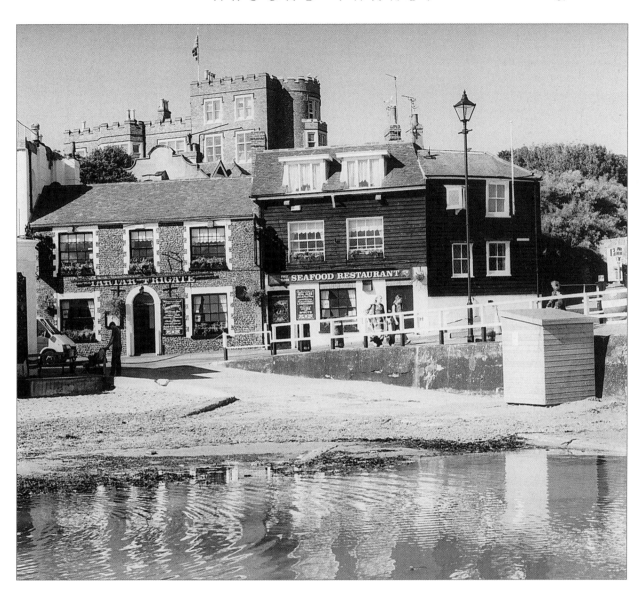

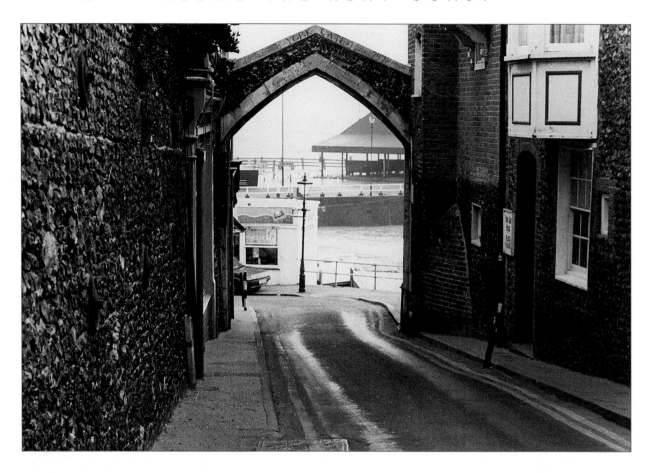

A place of old-world charm and pleasant surprises, Broadstairs is quite distinctive among Kentish seaside resorts. Here we see the York Gate, a portcullis erected originally at the time of Henry VIII, so it is said. The date on the arch, however, reads 1797, so perhaps what we see is a later adaptation. The building to the right of the gate is a cinema, one of the smallest in the country.

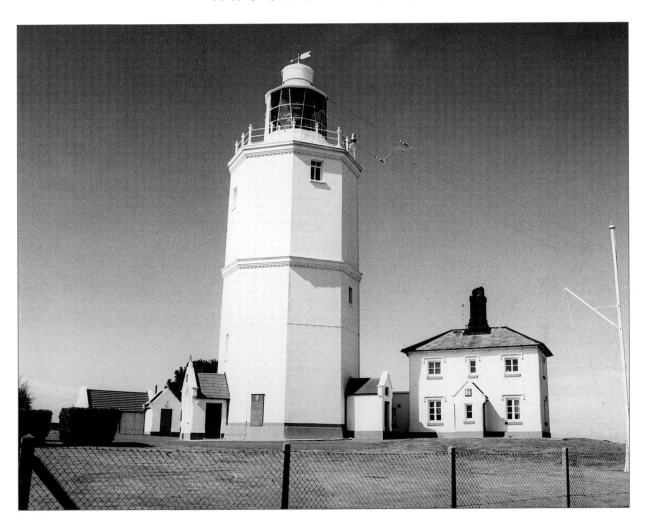

Beyond Broadstairs, on the North Foreland, stands this impressive lighthouse with its accommodation nearby. A light was first established here as long ago as 1499. This latest tower is similar in design to the South Foreland Lighthouse seen in the previous chapter. This one is also open to the public during the summer, and has the distinction of having been the last manned lighthouse in the country, being converted to automatic operation as recently as 1998.

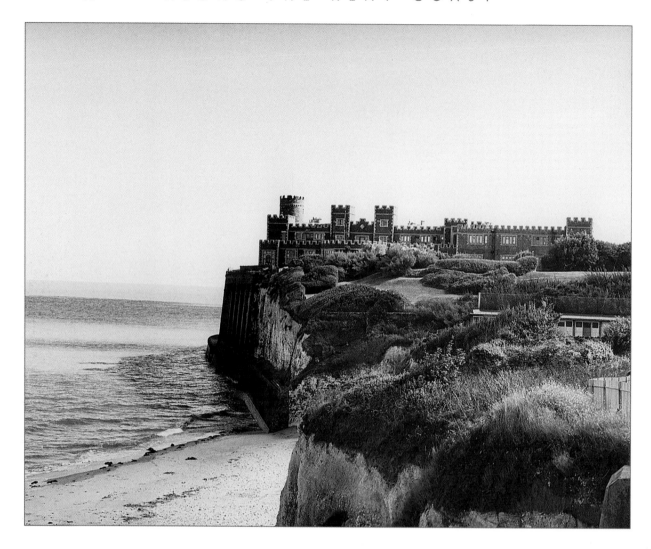

Kingsgate Castle is a fine imposing building in a superb location but it's not what it seems. Built in about 1860 Kingsgate Castle is, and always has been, a private residence, constructed in this style during the heyday of 'follies'. This of course is a folly *par excellence*. Its only real historical claim to fame as far as I am aware is that it was once the home of Lord Avebury, who introduced bank holidays to Britain in 1871. Kingsgate Castle today is divided into private apartments.

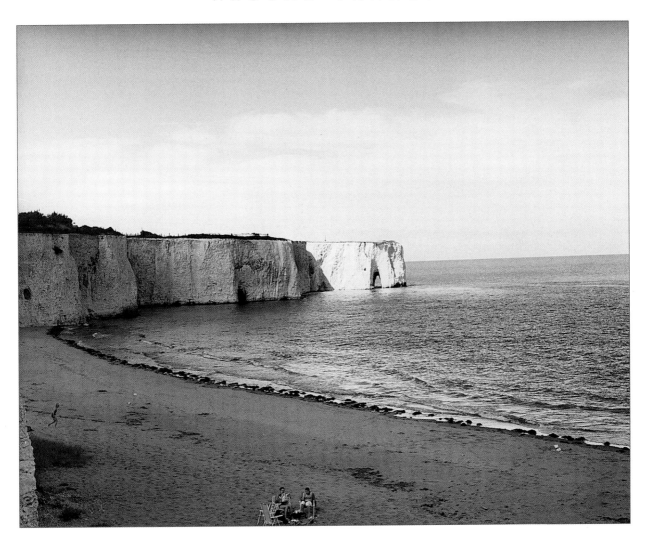

Above and overleaf: One of the features of the Thanet coast is its many sandy bays, fifteen in all. These pictures show Kingsgate Bay, a secluded, quiet, sandy beach backed by white chalk cliffs. Notice the very distinctive layering of the chalk in the natural archway. The bay is bounded by the spectacular Kingsgate Castle on one side and by the Captain Digby public house on the other. A walking and cycle route known as the Viking Coastal Way runs along the length of this coast, starting at Sandwich and continuing round to Herne Bay.

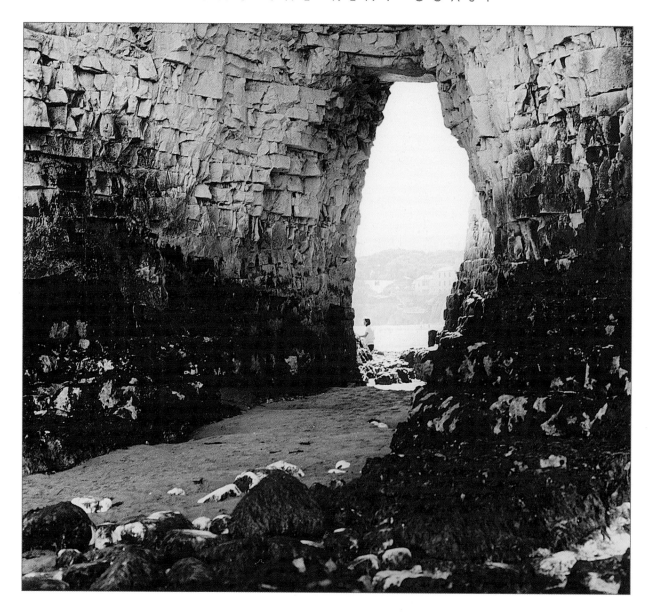

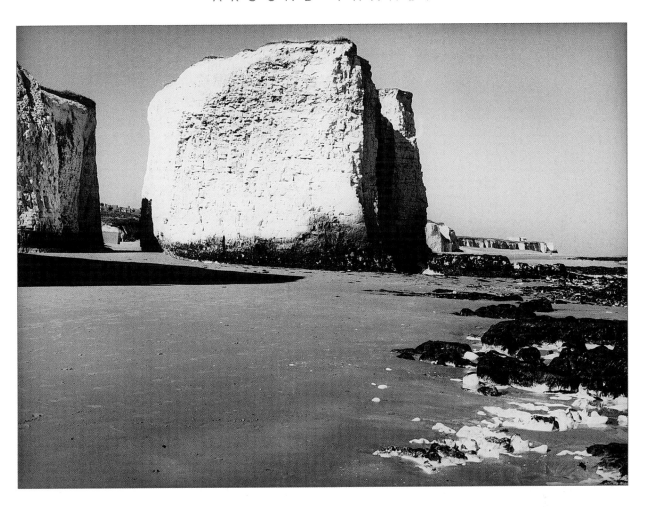

The exotically named Botany Bay lies between Kingsgate and Cliftonville. Spectacular chalk stacks stand sentinel-like above this popular sandy beach.

Above and opposite: Margate, one of the most traditional of English seaside resorts and among the first. It was here that the deck-chair and donkey rides were first introduced in the late eighteenth and nineteenth centuries, and the town's funfair, known for generations as Dreamland, is legendary. Times are a-changing though, and Margate is busy reinventing itself. No doubt the beachside fast food joints as pictured here will continue, but at the time of writing Dreamland is set to close and the town plans to move away from its Punch and Judy, 'kiss me quick'-hatted, candyfloss image to something more highbrow. The ornate Victorian ironwork has been given a lick of paint, the Old Town is being transformed and a sea-front visitor centre explains the town's link with the famous sunset-besotted artist J.M.W. Turner and tries to predict what the future has in store.

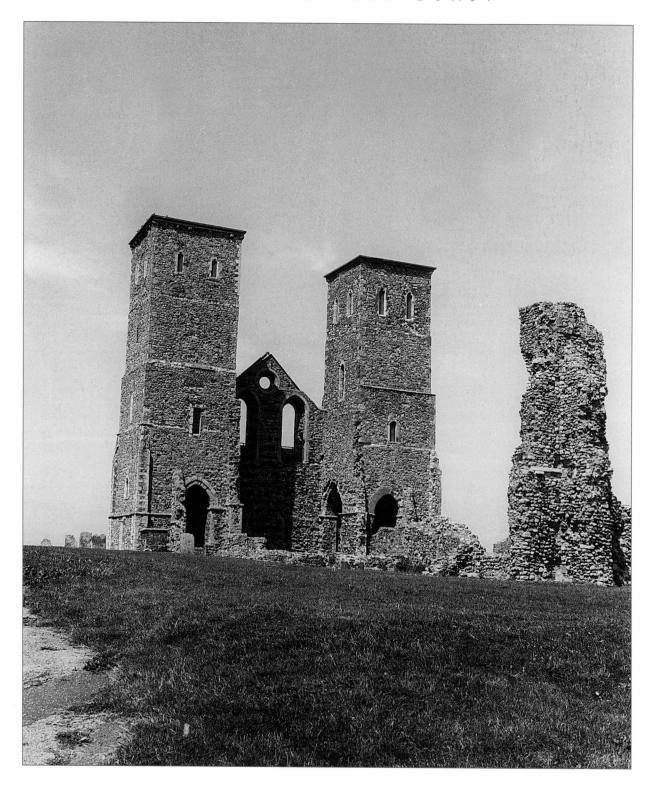

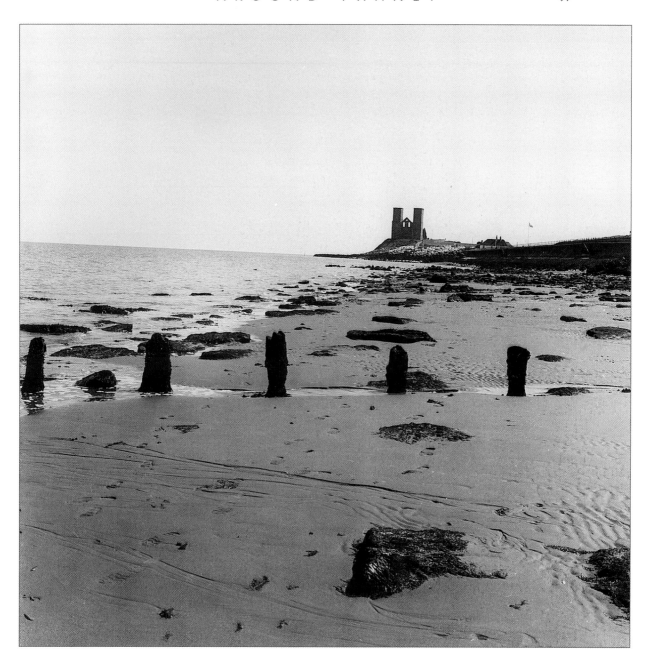

Above and opposite: Few sights on the Kent coast are as starkly impressive as the twin towers of the Saxon church at Reculver. Protected against the ever-advancing sea by a sturdy sea wall, the towers are an important navigational aid on an otherwise featureless stretch of coast. The church was built from material stripped from the old Roman fort that guarded the now silted-up Wantsum Channel. An interpretation centre at Reculver describes the history of the site and the wildlife that lives on this shore, which is now a nature reserve.

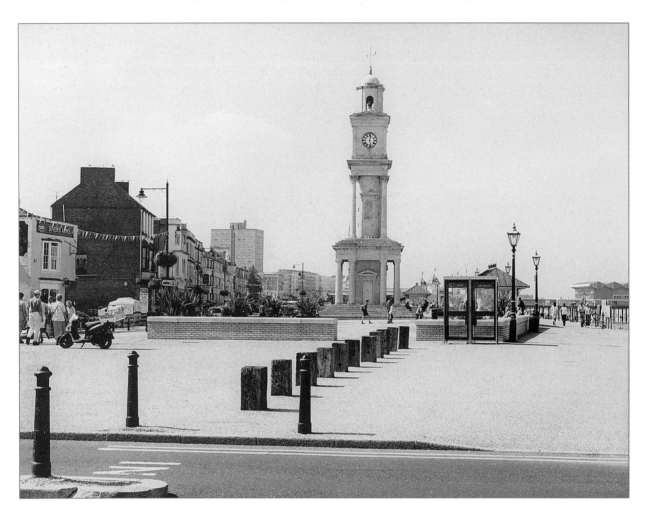

Herne Bay sea front with its distinctive clock tower. Once a rather faded resort, Herne Bay has undergone something of a facelift recently, with the bandstand restored, new sea-front gardens laid out, the clock tower cleaned up and a small harbour constructed. Every Saturday Kent's largest general outdoor market brings in throngs of shoppers with an eye for a bargain.

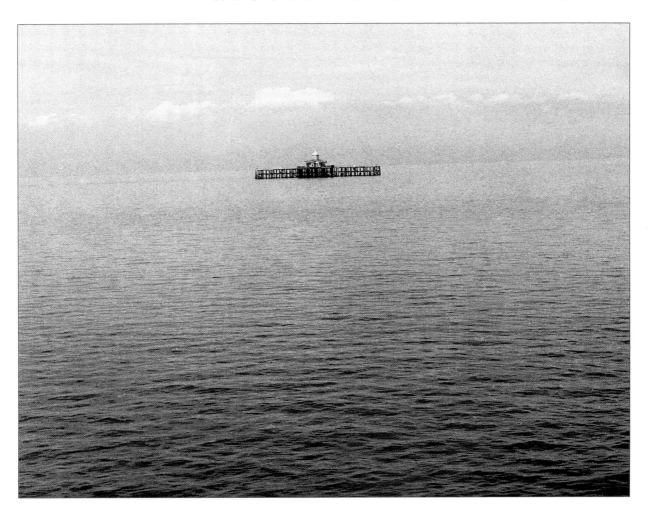

Once the second longest in the country, Herne Bay Pier was literally washed away during winter storms in 1979. The beach and sea front were covered for days with the smashed and washed-up remains of the once-proud construction. Today the pierhead is all that remains – stranded out at sea, abandoned and frequented now only by gulls and fishermen.

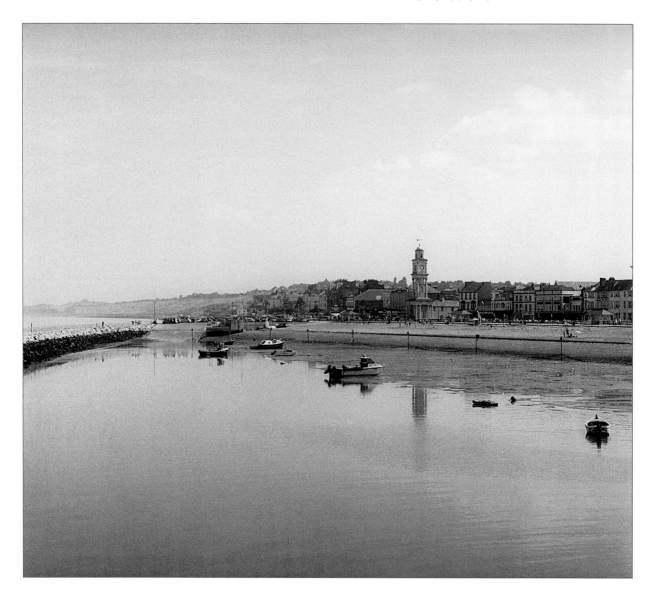

A final view of Herne Bay from the new harbour wall which doubles as a sea-defence measure, protecting the previously vulnerable sea front that has several times suffered from the effects of North Sea storm surges.

SWALE

To travel up the Swale is to leave behind the open expanse of the North Sea and move into a world of muddy creeks and bird-haunted marshes. From Whitstable, with its weatherboarded cottages right next to the beach, its busy little harbour and world-famous oysters, our journey takes us around a flat and lonely coastline to the pretty town of Faversham, whose cluster of medieval and eighteenth-century buildings offers a good centre for walking the Swaleside paths in either direction. You can wander along to the marshes rich in wildlife, lazy inlets, muddy boatyards and abandoned ferry crossings of this narrow channel that separates mainland Kent from the seemingly remote and lonely isle of Sheppey. Here, a brown-sailed barge can still sometimes be seen plying the waterways from a traditional pub serving local beer, while hop gardens, blossom-filled orchards and oast-houses can be found within sight of modern industrial developments.

In this chapter we concentrate on a representation of the subtle and varied charms of this coastline. Perhaps not spectacular as such (though if you've witnessed a sunset across the mudflats near Faversham you might disagree), it's certainly attractive in a quiet, mellow sort of way.

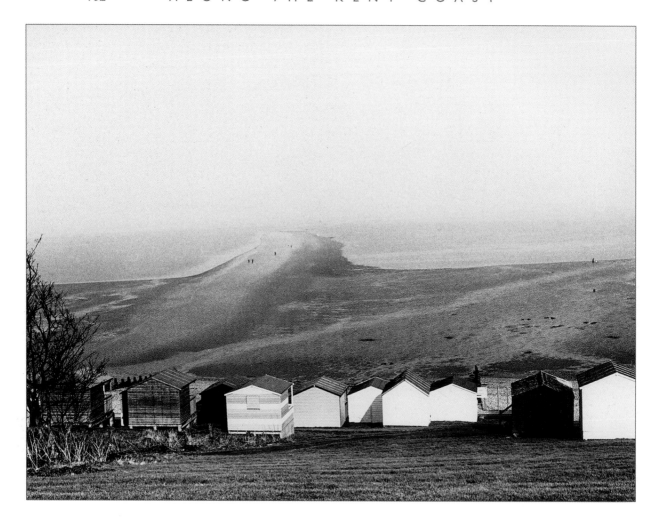

The Street, as it's known, is a long finger of shingle jutting out into the sea from Tankerton near Whitstable. It is actually an outcrop of clay that has intercepted shingle travelling by longshore drift along the coast, the effect being to create this shingle bar. The Street is a popular walk locally and many wander along the half mile or so to the end, collecting shells washed up here. Unpredictable currents around the end of The Street make swimming dangerous.

Above and overleaf: Whitstable has always had an intimate relationship with the sea. A popular sailing centre and sought-after seaside location, this little town has lots of character, as can be seen in its varied architecture and narrow alleys.

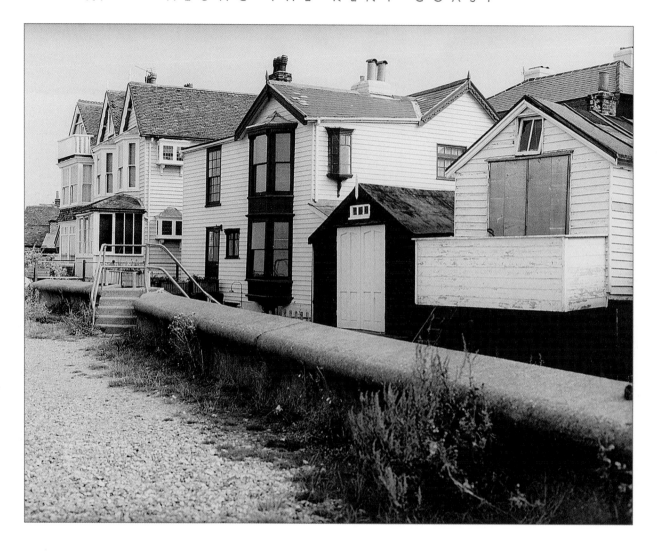

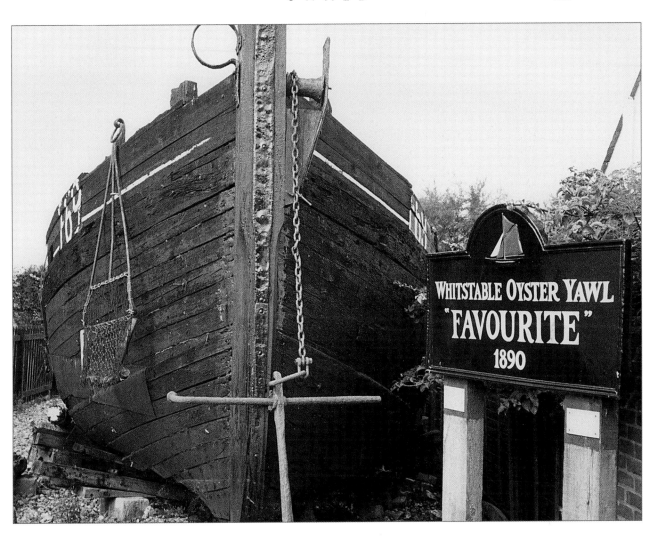

Whitstable's main claim to fame is its oysters, farmed here since Roman times. This old Oyster Yawl, the *Favourite*, was built in 1890 by the Whitstable Shipping Company for Pikey Carden, landlord of the Fisherman's Arms. The *Favourite* dredged the oyster beds until the Second World War when it was machine-gunned below the waterline. Today the yawl is preserved by the Favourite Trust and is open to the public.

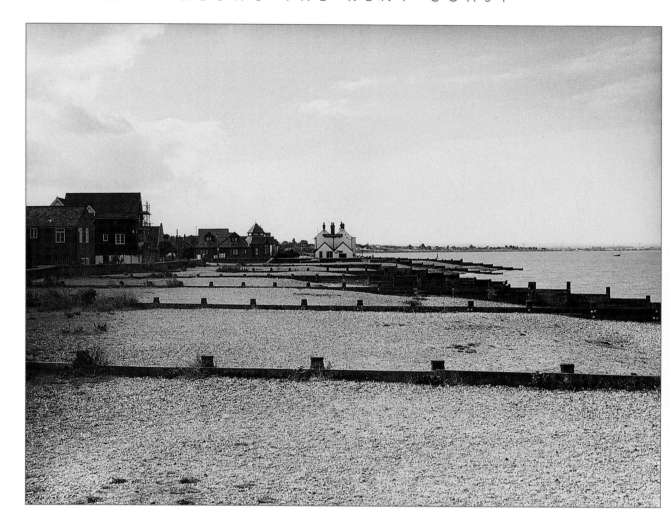

The Old Neptune inn sits by the seashore, isolated and exposed to all that nature can throw at it.
Flooded by storm surges, partially demolished by the pounding of the sea and locked in ice when the
sea froze at Whitstable in 1956, this sea-front pub is a true survivor.

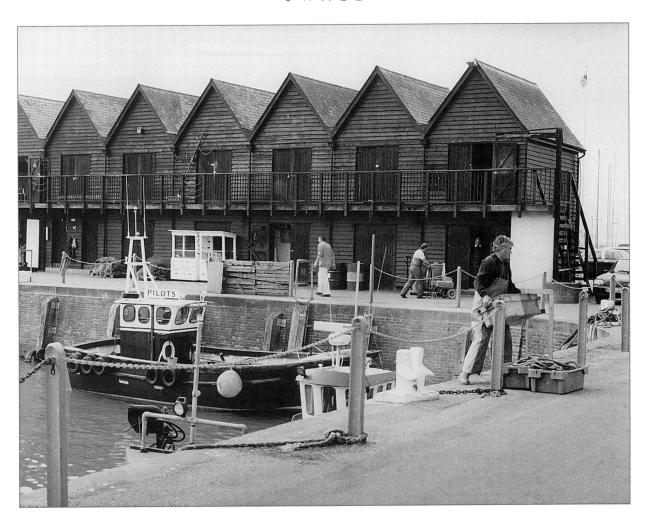

The bustling little working harbour at Whitstable is used by a local civil engineering company and the town's oyster trade, among others. In the vicinity of the harbour are the largest oyster beds in Europe, which are now back on form after setbacks caused by pollution and the devastating storm of January 1953. There is an Oyster and Fishery Exhibition on the East Quay, and an Oyster Festival is held in the town every July.

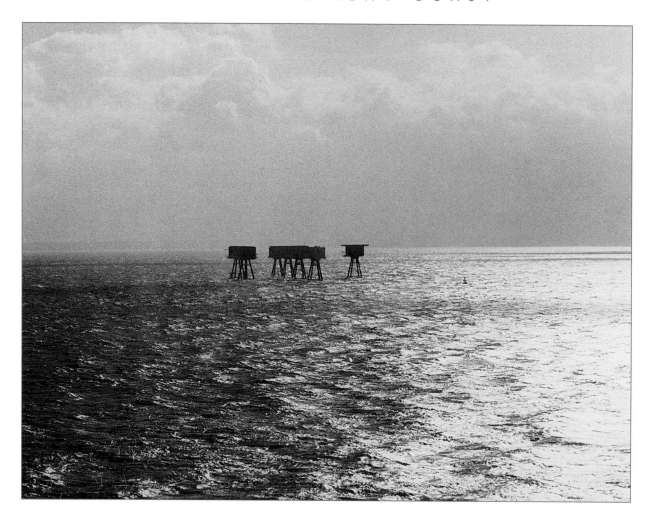

Some of the remaining Maunsell Sea Forts, occupied gun emplacements erected in the Thames Estuary
during the Second World War. These were decommissioned in the 1950s but have occasionally been
occupied since, most notably during the 1960s when the pirate Radio 390 operated from here.
Originally all the forts were connected by walkways, but these were deliberately destroyed to prevent
those 'boarding' a tower gaining easy access to the others. If current plans come to fruition these
towers will soon be joined by other skeletal structures on the horizon. There are proposals to create a
wind farm in this vicinity in the near future.

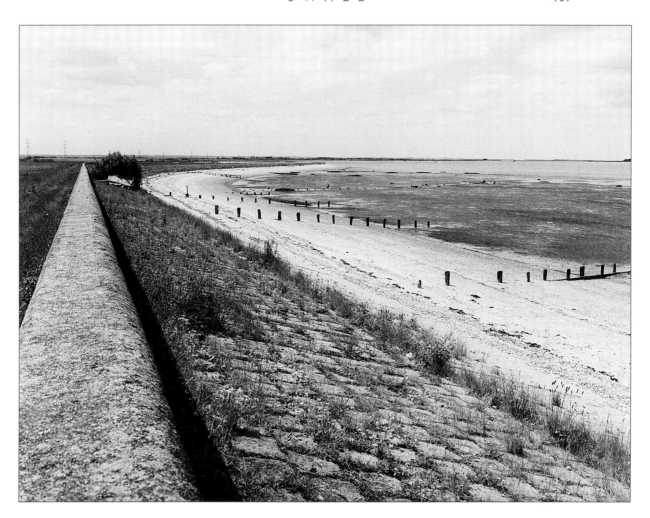

Between Whitstable and Faversham a long and lonely walk passes through the South Swale Nature Reserve. Mudflats here attract a variety of waders and wildfowl, particularly Brent geese. A regular sailing barge race is held along this coast, recalling the heyday of this form of transport.

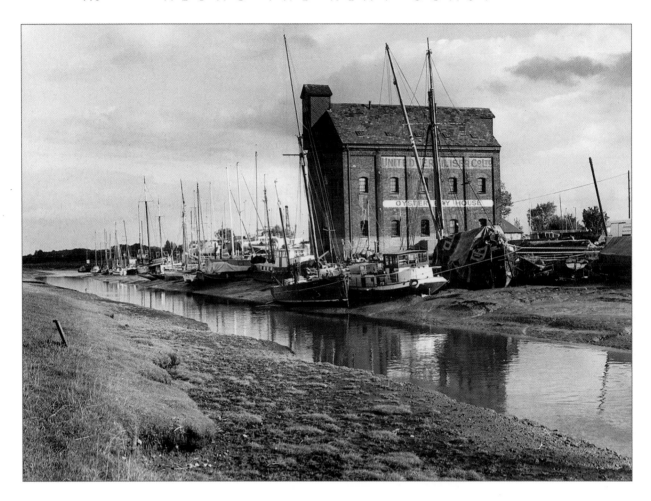

Faversham Creek in tranquil mood. The gateway to a coastline of creeks and boatyards beyond.
Faversham itself boasts the country's oldest brewery, Shepherd Neame, and an old gunpowder mill, well
restored and a reminder of the town's past role as a centre of Britain's explosives industry.

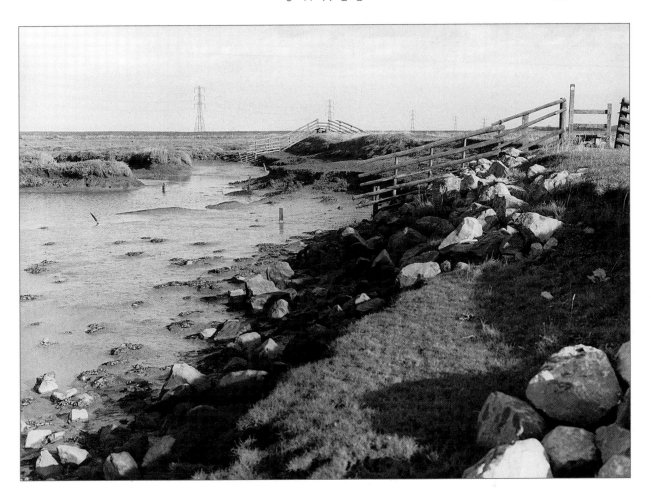

This landscape near Faversham Creek is typical of the open undemanding walking offered by this stretch of coastline, along which runs the Saxon Shore Way.

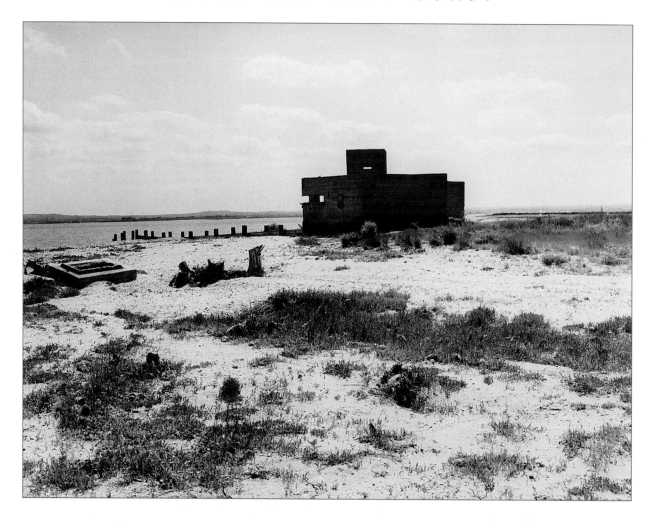

'High Tide Fort', a Second World War fortification situated on the south-eastern tip of the Isle of Sheppey at Shell Ness. From here access to the Swale could be guarded against enemy incursion. The hills of Kent can be seen in the distance.

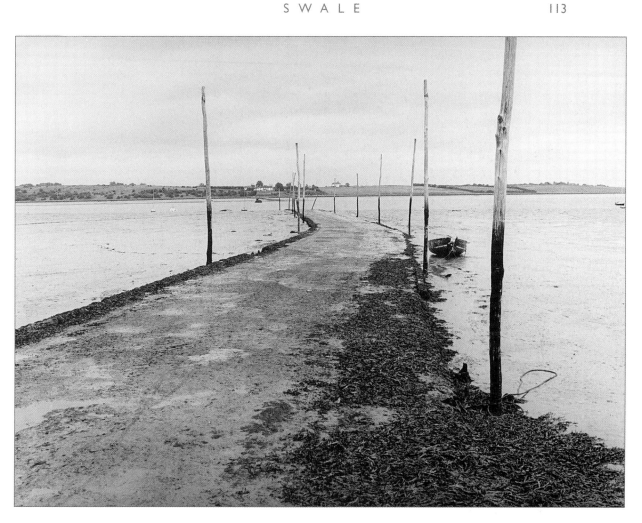

The old Harty Ferry landing, looking from mainland Kent across to Sheppey. The crossing is long disused, since the King's Ferry Bridge to the west now provides a more secure means of reaching the island.

Back across to Sheppey and the reed beds and bird sanctuary at Elmley Marshes on the south coast of the island. This Royal Society for the Protection of Birds reserve attracts thousands of widgeon, teal, geese, redshanks, lapwings and shovellers every year.

Opposite: Looking over to Sheppey from the coast between Conyer and Sittingbourne, a typical Swaleside view.

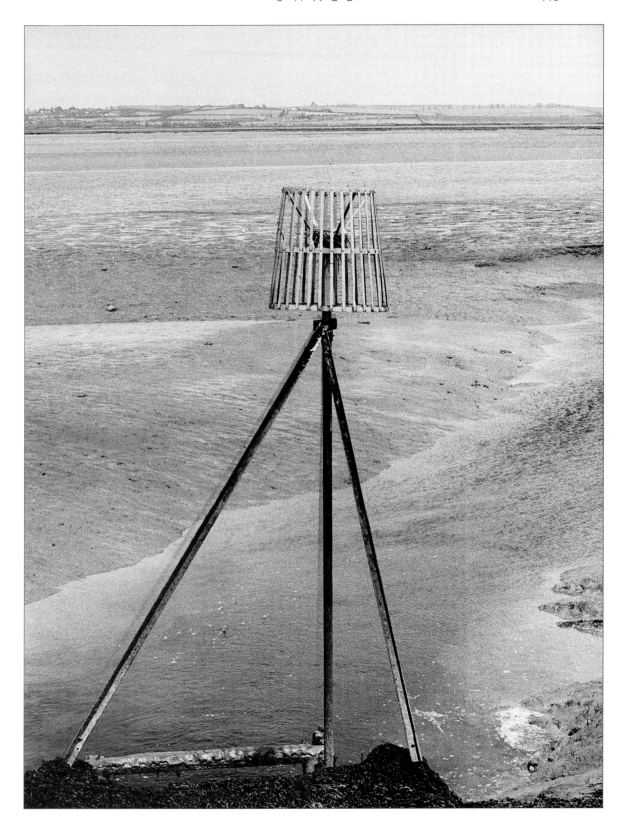

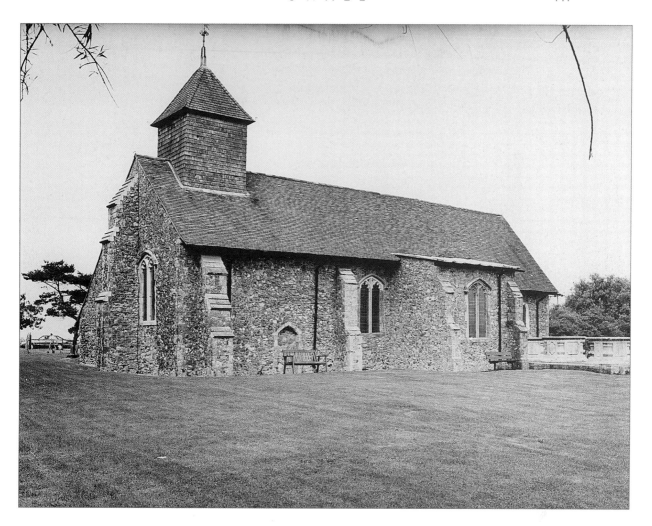

Above and opposite: The little church of St Thomas, on the Isle of Harty, south Sheppey, described sometimes as Kent's remotest church, is certainly among the county's most attractive. Although earlier in origin, the current building is thought to date from 1089. In the Lady Chapel, seen here, resides the church's most treasured possession, a fourteenth-century oak chest finely sculpted with a carving of jousting knights and their entourage. Legend claims that the chest was found floating in the Swale. In August 1987 the chest was stolen. Following a television broadcast about the theft the chest was identified in a Phillip's auction room by a member of staff just three days later. The valuable chest is now safe behind a newly constructed security screen designed locally.

A final view from the Swale. Harty Ferry landing, with a sprit sail barge in midstream and the mainland of Kent beyond.

MEDWAY & THAMES

Approaching the end of our journey along the Kent coast we come to the estuaries of the Medway and the Thames. In the main this area cannot be described as beautiful, moody or atmospheric, but in places it is certainly striking, varied and historically interesting.

From muddy banks and rotting wrecks we move into the urban landscape around the River Medway, the river that divides Kent into the ancient realms of Kentish men and Men of Kent: which you belong to depends on which side of the river you were born.

Here in Medway we find the historic dockyard at Chatham, with its ships, submarines, ropery and wealth of maritime exhibits. Nearby Rochester boasts a fine cathedral and an ancient castle. Along with the surrounding countryside this is a city that lives and breathes Dickens, since it was here that he wrote many of his best-known novels. The great author loved this part of Kent, along with Broadstairs, and spent the last twelve years of his life in the area before finally passing away at Gads Hill, Rochester.

Along the Thames, passing marshes and fields destined to disappear beneath massive new housing developments and possibly a new airport for London, reminders of the past still linger. Abandoned and melancholy forts built in the nineteenth century stand unused, while in and around Gravesend the lives and times of General Gordon of Khartoum and the Native American princess Pocahontas, both former local residents, are remembered for the benefit of local pride and the interested visitor alike.

As coast finally becomes river, an industrial landscape begins to dominate, until starkly towering ahead stands the imposing suspension bridge at Dartford that links Kent and Essex and marks the end of our journey along the Kent coast. A journey that started among the tiny fishing communities on the isolated shingle promontory of Dungeness has brought us via breezy channel cliff tops, busy seaside resorts and quiet backwaters to the bustling hub of twenty-first-century Britain.

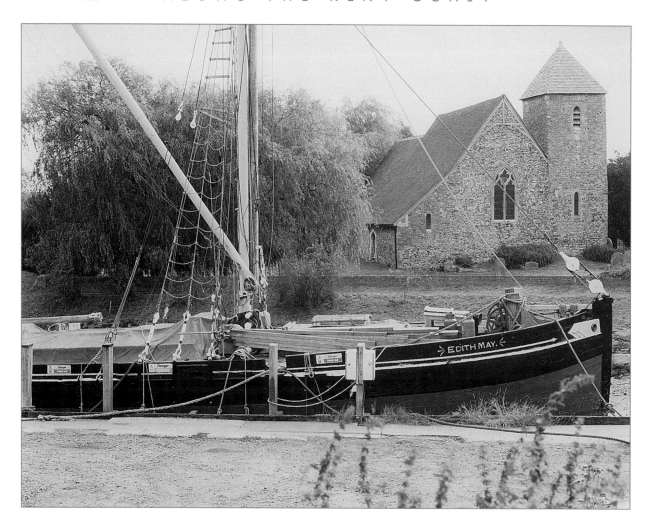

An oasis of rural beauty, this is Lower Halstow church with *Edith May* in the foreground. In the seventeenth century Lower Halstow gained a rather gruesome reputation: it was just off the coast here that those coming from abroad suspected of carrying the dreaded plague were quarantined in special vessels anchored offshore for that purpose. Those who died on board were buried on a nearby island known ever since as Deadman's Island.

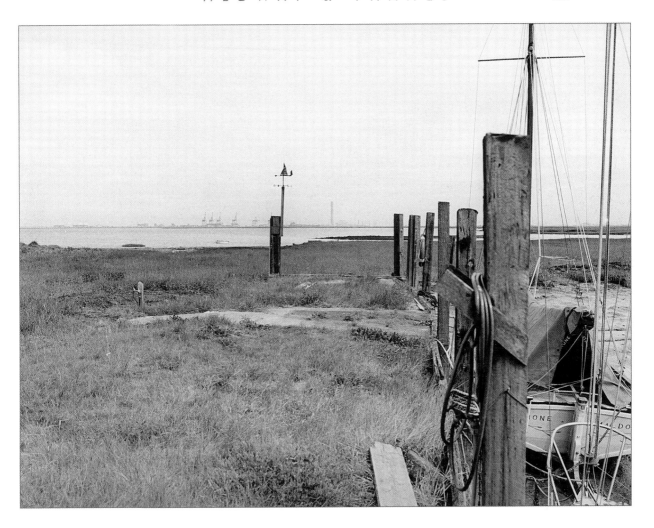

Shoregate Wharf with the industrial landscape of the Isle of Grain beyond.

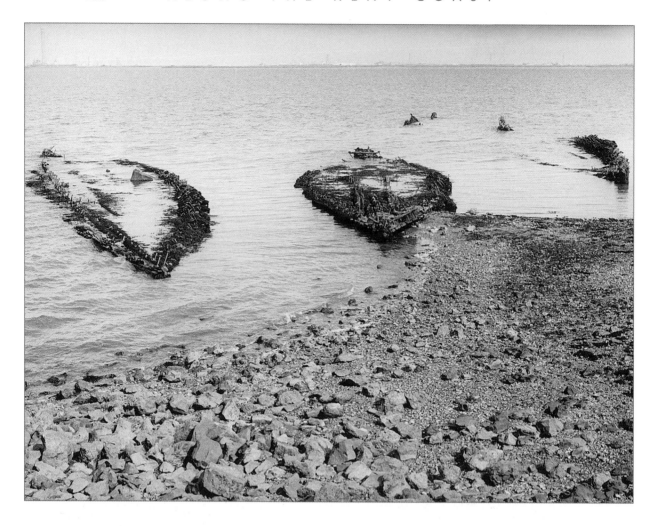

Rotting wrecks emerging from the receding tide.

Opposite: HMS *Cavalier*, one of the prime exhibits at the Historic Dockyard at Chatham. *Cavalier* was constructed in 1944 and saw action off northern Norway, for which it was awarded the Battle Honour 'Arctic 1945'. *Cavalier* was only decommissioned in 1972, the last Second World War destroyer operated by the Royal Navy. Elsewhere in the precincts of the Historic Dockyard can be found the submarine HMS *Ocelot*, built in 1964 and retired in 1981. Both ships can be explored by the public. Chatham was once the most important naval dockyard in the country and is now said to be the most complete dockyard relating to the 'age of sail' anywhere in the world.

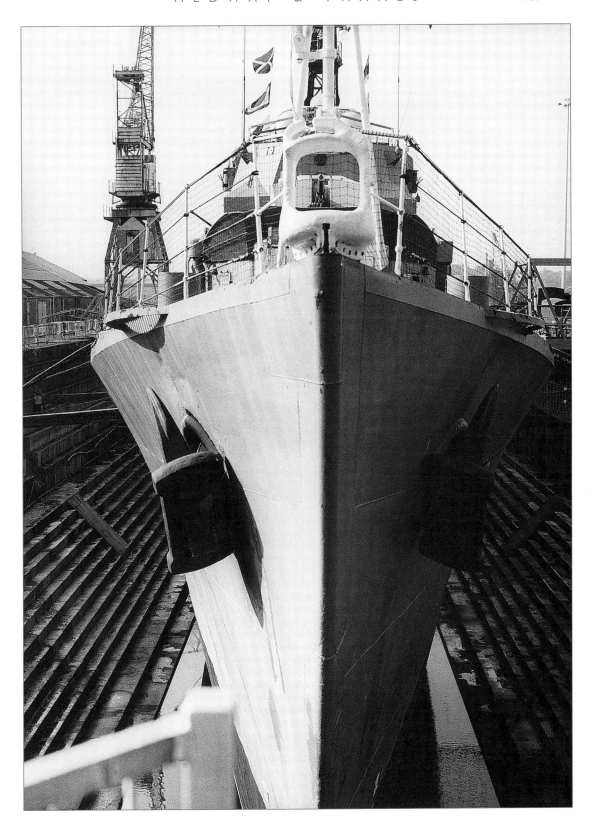

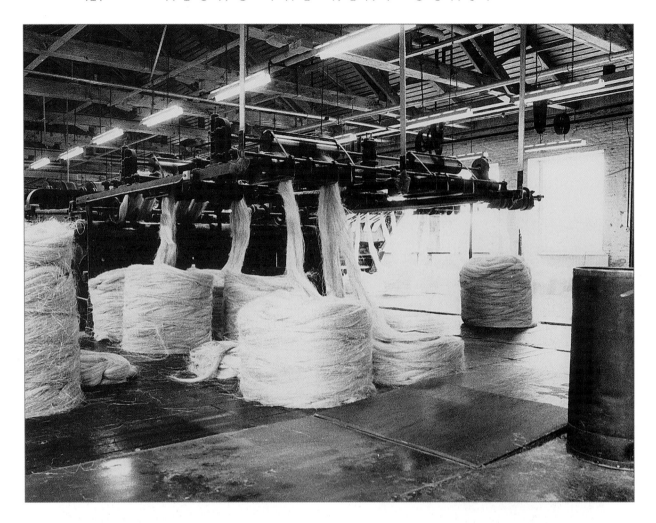

The Ropery, situated in the Historic Dockyard. Rope has been made in this quarter-mile-long building since 1618. Great quantities of rope were needed by the Royal Navy during the age of sail, since up to 20 miles of rope were needed for the rigging of a single ship. The Ropery is still commercially active today and the manufacturing process can be watched by visitors to the building.

Opposite: Rochester Cathedral seen from a vantage point at the nearby castle. This magnificent cathedral is England's second oldest, founded in 604. Most of the present building is of Norman and Gothic origin. At the time of writing the first fresco to be painted in an English cathedral for 800 years is near completion: its theme is baptism. Note the intriguing effect created by the shadows of the trees across the pavement and lawn near the bottom of this picture.

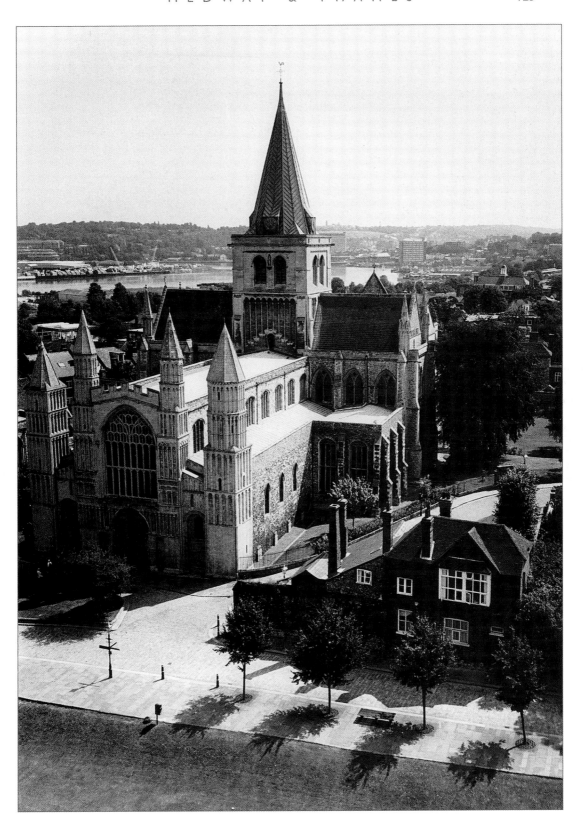

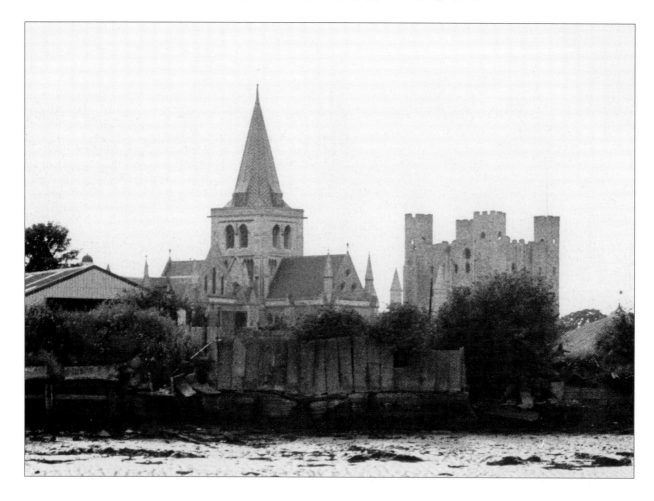

The dramatic skyline created by the proximity of Rochester's cathedral and castle. The castle is of Norman origin and has one of the tallest keeps in the country at 113 feet high. In places the walls are 12 feet thick, which no doubt helped it survive a ferocious siege by King John in 1215. Today the castle is owned by English Heritage and open to the public.

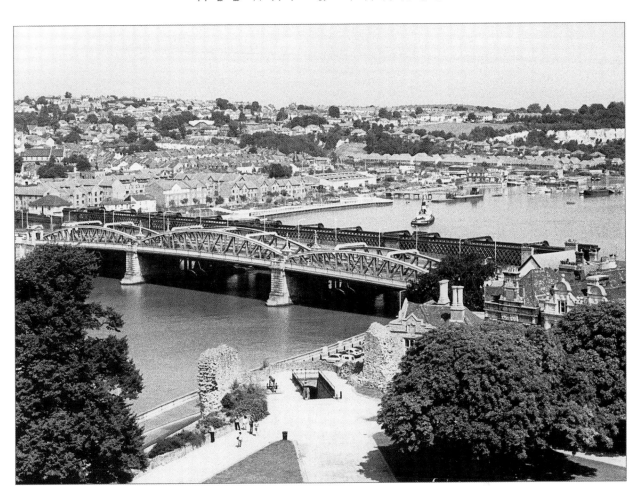

Across the Medway at Rochester. The town's main claim to fame is probably its association with Charles Dickens. Here he wrote *Great Expectations* among other works and was working on a novel entitled *The Mystery of Edwin Drood* when he died at Gads Hill in 1870. The town celebrates the famous author in two festivals, the Summer Dickens Festival and Dickensian Christmas, when the town centre takes a step back into Victorian times. Additionally, a fine Elizabethan building called Eastgate House contains a Charles Dickens Centre, which is open during the summer season.

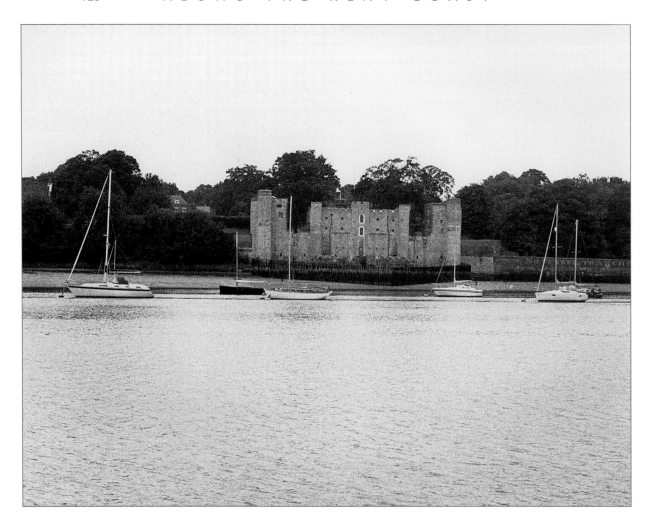

Downriver, back towards the coast, stands the attractive Upnor Castle. Built originally in 1559, the castle's role was to defend the naval dockyard at Chatham from attack. However, when tested by the arrival of a Dutch raiding party in 1667 the castle proved ineffective. An audio-visual display in the castle tells the story of the raid.

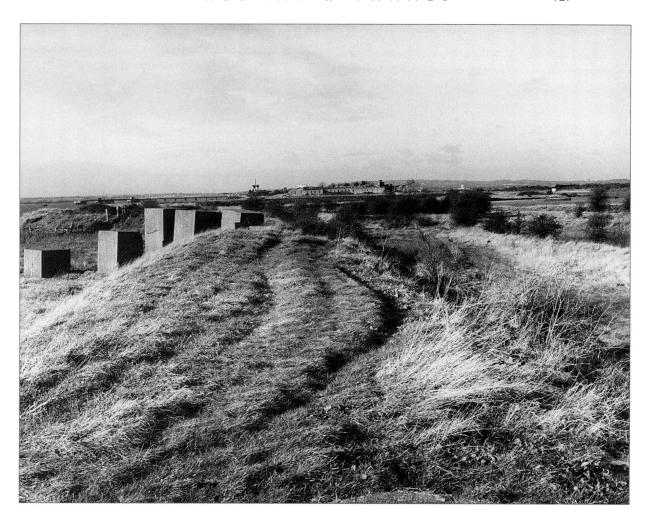

Above and the following page: Cliffe, set on raised ground above the Thames, offers fine views of the traffic up and down the river. Its location led to its being selected as a site for one of the forts constructed in the mid-nineteenth century by General Gordon. Cliffe Fort is in a particularly lonely and melancholy location. The rails running down into the Thames at Cliffe were for launching Brennan torpedoes. These were very early wire-guided missiles introduced in the 1890s. They were very slow and not particularly effective. The marshes near Cliffe are in the news at the time of writing as a strong contender for the site of London's next airport. This proposal is vehemently opposed locally.

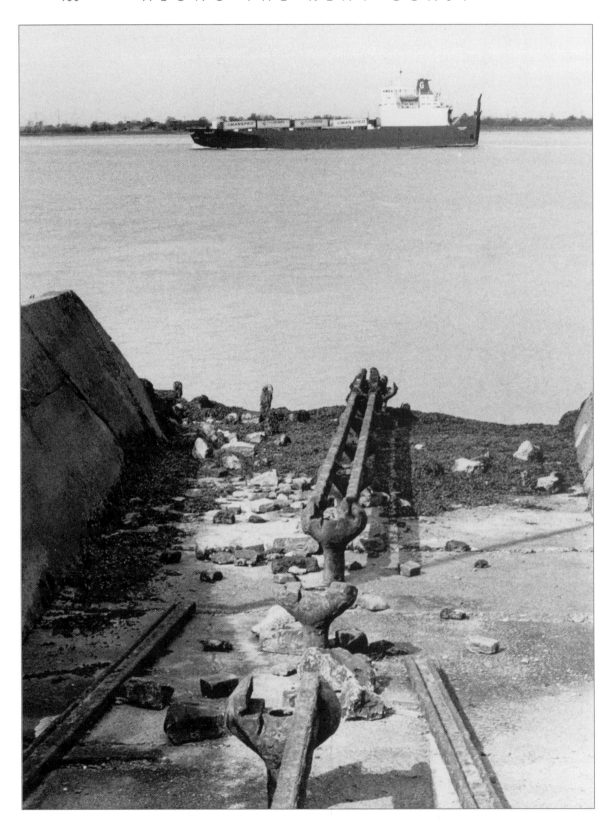

Vessels past and present.

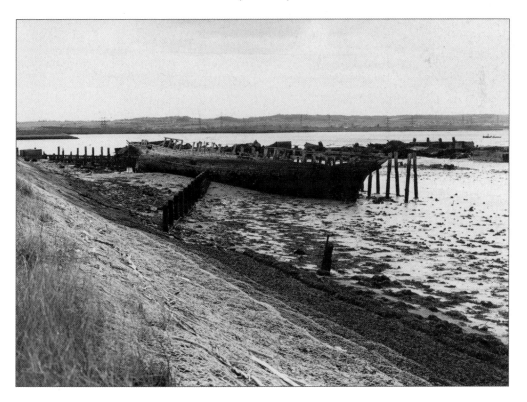

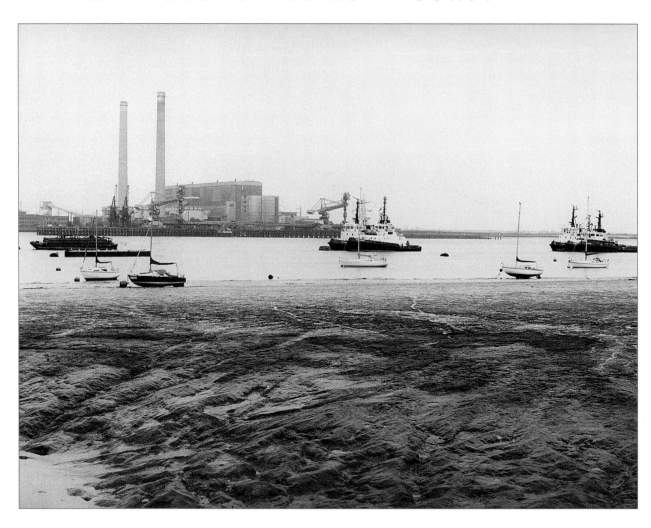

River scene near Gravesend.

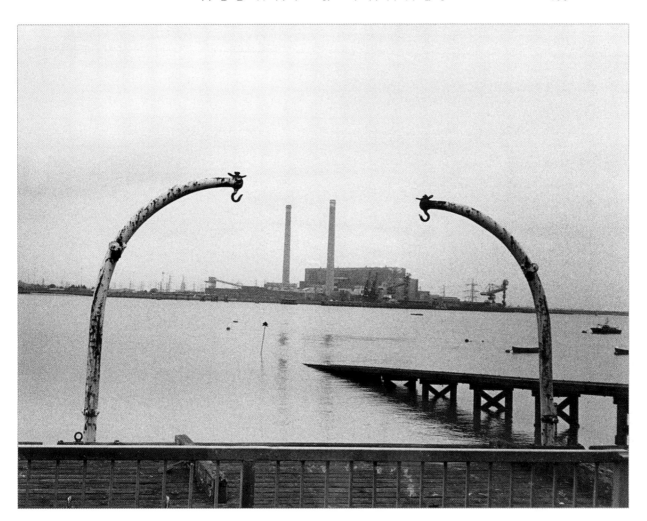

An old ferry landing at Gravesend. Since the fourteenth century a ferryman had the monopoly of waterborne passenger traffic across the Thames to Tilbury, a distance of just a few hundred yards. Today of course there are crossings by bridge and tunnel at Dartford, taking a vast amount of traffic virtually non-stop.

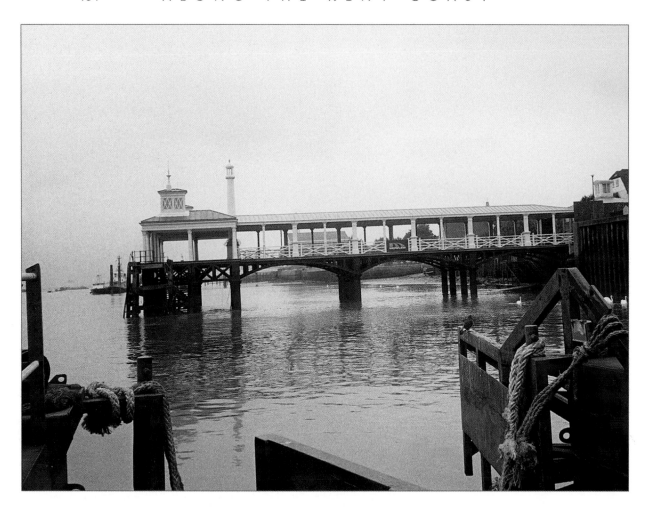

The Town Pier at Gravesend is the oldest surviving cast-iron pier in the world. It is now being restored to its former Victorian splendour.

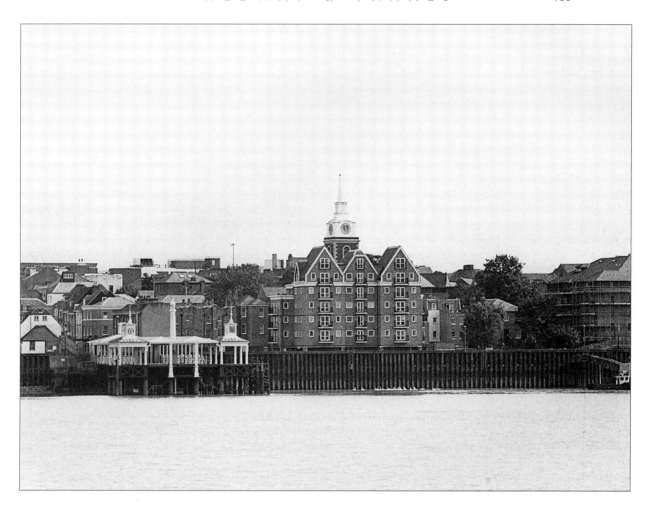

The Town Pier from the river with the attractive and imposing St George's Church to the right. In the churchyard of St George's is a bronze statue to the Native American princess Matoaka, better known by the nickname her father gave her, Pocahontas, which meant 'playful one' in her tribal language.

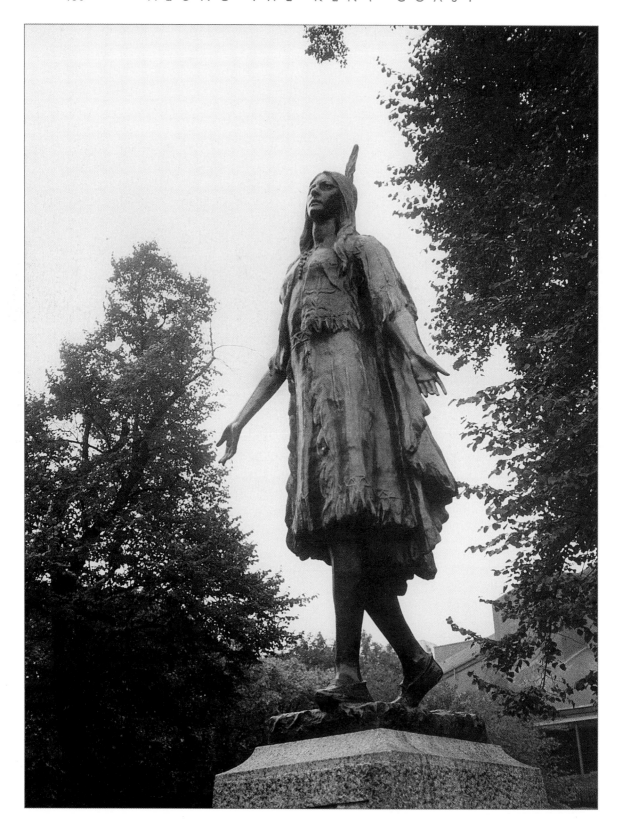

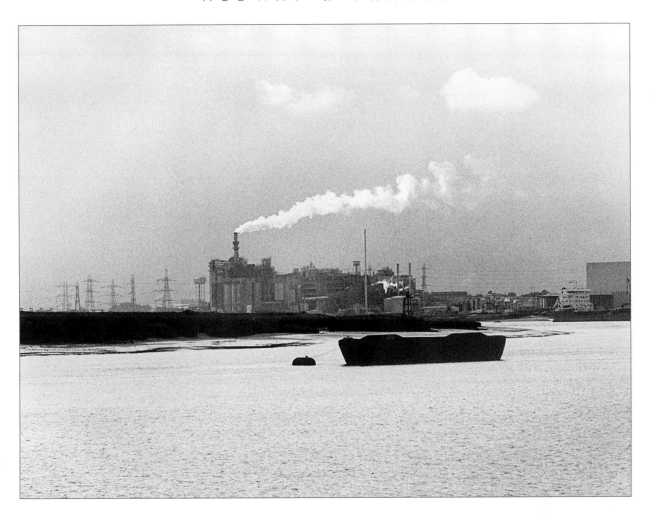

Above: Gravesend: industrial riverscape.

Opposite: This statue of Pocahontas was unveiled in 1958 by the Governor of Virginia in memory of her life. The princess is best remembered for intervening to save the life of Captain John Smith who had been captured in Native American territory. Two years later Pocahontas was held captive in the English settlement of Jamestown, Virginia, in return for payment of a ransom by her father. Pocahontas seemed to take to life in the colony, however, and in 1613 was the first of her race to be baptised. Renamed Rebecca, she married John Rolfe in 1614 and gave birth to a son. In 1617 Pocahontas came to England and lived at Gravesend for a year until she died suddenly and mysteriously, possibly of plague. She was buried in St George's churchyard, but no one knows where exactly.

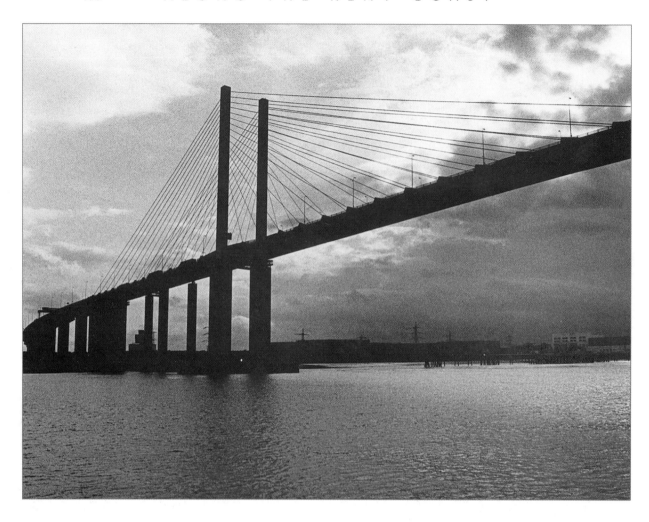

Above and opposite: Leaving Kent behind. The huge, dramatic, imposing bulk of the Dartford crossing, in use day and night and one of the longest such suspension bridges in the world, marks our journey's end.

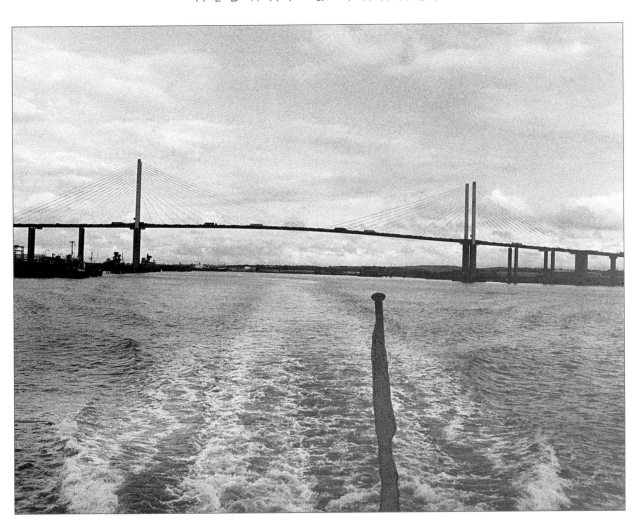

NOTE ON THE PHOTOGRAPHS

The majority of the photographs for this project were taken on a medium format camera, either a Yashica 120 Twin Lens or a Mamiya 645, producing a negative of higher resolution than the smaller 35mm format. However, some equally compelling shots were achieved with my Olympus OM2, and, a treasure of a camera for its size and picture quality, the Olympus XA.

Preferred film was mostly Ilford FP4 or Ilford HP5 (just occasionally Fuji Neopan 1600, for low light conditions) printed on Ilford Multigrade III or Multigrade IV paper.

The use of filters was kept to a minimum and then only for the occasional use of a yellow, where I thought that it might enhance the shot by separating barely perceptible cloud from an otherwise plain and uninteresting sky. I always prefer to see the soft billowing clouds in the viewfinder as I take the shot; those situations are not always guaranteed just because one wants to take photographs.

INDEX